Iris and B. Gerald Cantor Art Gallery, College of the Holy Cross
ISBN: 0-9616183-1-0
ISBN: 978-0-9616183-1-5

Catalogue design: Lore Devra Levin, Associated Asia Investments Limited

Catalogue copy editor: Gregory Nosan

Front cover and frontispiece: *Bouquet Final, No. 2* (Final Flower, No. 2), 2001 (cat. 15).

Page 10: *Funghi Porcini, No. 4* (Porcini Mushrooms, No. 4), 1997 (cat. 8).

Back cover: *Weather and Sky, No. 5,* 2000 (cat. 13).

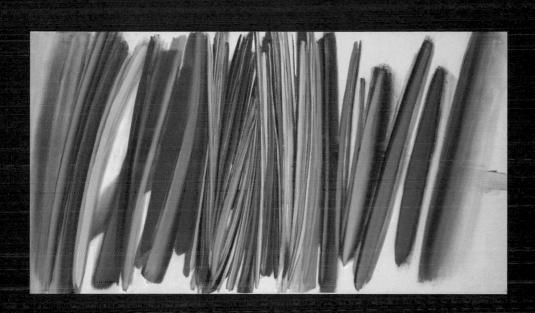

The Spiritual Landscapes of Adrienne Farb, 1980-2006

Edited by Jay A. Clarke and Joanna E. Ziegler
With contributions by Christopher A. Dustin, Charlotte Eyerman, and Erin Murray

Exhibition organized by the College of the Holy Cross, Iris and B. Gerald Cantor Art Gallery
Curated by Jay A. Clarke, Roger Hankins, and Joanna E. Ziegler

Contents

Director's Preface

For nearly three decades, Adrienne Farb has produced a substantial body of work that serves as a kind of handprint of her presence, registering her memories of places and observations of historical and contemporary art onto countless canvasses, sketchbooks, and sheets of paper with skill, conviction, and purpose. We are pleased and honored to present this focused survey of twenty-nine important paintings that Farb created while living in Paris, London, and New York from 1980 to the present. We are also doubly honored to have published this beautiful catalogue, which was researched and written by a remarkable team of scholars including Joanna E. Ziegler and Christopher A. Dustin, faculty members at the College of the Holy Cross, and Jay A. Clarke, a curator at the Art Institute of Chicago, and Charlotte Eyerman, a curator at the Saint Louis Art Museum, both of whom are distinguished alumnae of Holy Cross. Holy Cross alumna Erin Murray contributed the invaluable chronology.

The Spiritual Landscapes of Adrienne Farb, 1980–2006 is the result of many individuals' dedicated, hard work throughout all stages of its creation and production. First of all, our appreciation and thanks go to the artist herself, who graciously extended full access to countless paintings, drawings, and details of her life. Our deepest debt is to Joanna E. Ziegler and Jay A. Clarke, who originally proposed this exhibition and worked tirelessly to bring it, and this publication, to life. At Holy Cross, our special appreciation goes to Interim Dean James M. Kee and President Rev. Michael McFarland, S.J., for their encouragement of our exhibition program. Finally we recognize the continued, generous support of Iris Cantor and the Cantor Foundation, which has established and endowed the Iris and B. Gerald Cantor Art Gallery at the College of the Holy Cross for over twenty years.

Roger Hankins
Director
Iris and B. Gerald Cantor Art Gallery

Introduction and Acknowledgments

Jay A. Clarke and Joanna E. Ziegler

The work of Adrienne Farb represents one of the most important—yet contentious—strains of Modernism: abstract art. She pursues artistic values that during the twentieth century were received skeptically at first, then enthusiastically, and in the last two decades, critically. Her paintings are neither politically charged nor saturated with theoretical meaning; they are serious, coherent, and intense expressions of sensuous color and shape. It was our sense that this highly original body of work deserved more of the kind of scholarly attention that this publication and its accompanying exhibition can provide.

We have assembled four essays with four quite different perspectives on Farb's work. Joanna E. Ziegler, Professor of Visual Arts at the College of the Holy Cross, who has known Farb since their undergraduate days at Brown University, approaches the artist's biography not by ferreting out personal or sociopolitical motives but rather by exploring the foundations of her "aesthetic"—the sources of her particular expressiveness, her unique abstraction. Charlotte Eyerman, Curator of Modern Art at the Saint Louis Art Museum, takes up Farb's aesthetic production by addressing the role of place in her work in terms of actual geographic location (Paris and Italy) and by chronicling the artist's intimate "friendships" with important works of Western art. Christopher A. Dustin, Associate Professor of Philosophy at Holy Cross, offers thoughts on Farb's art and its power by exploring concepts—intuition and imagination—that help us better grasp the experien-

tial and aesthetic work of abstraction itself. Finally, Jay A. Clarke, Associate Curator of Prints and Drawings at the Art Institute of Chicago, places Farb's antitheoretical stance on painting in the context of contemporary scholarship on abstraction, looking at this mode's reception since (and problematic relationship to) Abstract Expressionism. Independent scholar Erin Murray has assembled an insightful chronology of Farb's life and work, summarizing, among other things, the significance of her various international relocations. Along with the chronology, the four essays constitute a range of critical and personal insights into Farb's vibrant accomplishment but also into the act and importance of looking itself.

Two threads run throughout this conversation: that of the importance of geographical place in the making of these works and that of the physical, internal characteristics of the paintings themselves. These issues have also been central to the exhibition, in which we have grouped objects based on their cities of production: Paris, London, and New York. While the majority of these works date from the last five years, the first was created in 1980. Our aim is not to present a retrospective of Farb's painted oeuvre but rather to show the genesis of her work over the past twenty-five years in its peculiarities but mostly in its rigorous consistency. We believe that viewers can better appreciate her works' subtle and powerful changes in style, scale, and formal density by considering these examples drawn from the full span of her career. We hope that, together, this publication

and exhibition will contribute to a better understanding of Farb's active and sustained contributions as a contemporary artist and also help the viewer, as well as the reader, to wonder about the significance of abstraction as an artistic choice in the early-twenty-first century.

Many individuals have contributed their help and expertise to make this project possible. At the College of the Holy Cross, we extend our sincere thanks to Timothy Johnson, Preparator and Exhibition Specialist; Paula Rosenblum, Administrative Assistant for the Iris and B. Gerald Cantor Art Gallery; and Katarina Wiegele, student and Gallery Assistant. We would like to thank Eleanor Binnall for helping procure illustrations; David Gyscek for his continued theoretical and practical help with this exhibition; James Kee, Interim Dean of the College, for supporting the symposium that accompanies this exhibition; and Margaret Nelson for technical assistance with numerous aspects of the digital formatting and communication.

For scholarly, professional, and aesthetic advice and research, we thank: Corinne Birman, Artex; Christian Carone; Vincent Demeusoy; Carter Foster, Whitney Museum of American Art, New York; Georgia Marsh; Stephanie Skestos, Skestos Gabrielle Gallery, Chicago; Rebecca Ruderman; and David Hamill, Brian Gilmartin, Jeff Lee, and Mary Ryan of the Mary Ryan Gallery, New York. Lore Devra Levin created an inventive and elegant design for this publication, and Gregory Nosan edited it with a rigorous and intelligent eye. Clément Bernard,

Adrienne Farb's husband, has contributed in myriad ways, establishing and maintaining an inventory of Farb's work and offering moral support all along the way. We also thank our spouses, Joe Vecchione and John F. K. Bradley, for their patience during our many hours of work and their watchfulness over the verbal and intellectual character of our essays.

Roger Hankins, Director, Iris and B. Gerald Cantor Art Gallery, was enthusiastic about this undertaking from the start and helped in many ways to realize it. He was instrumental in selecting the works for the exhibition and in arranging the production of the catalogue. Many of us involved in this project also owe a special debt of thanks to the late Kermit S. Champa, who gave us a belief in the transcendent act of "seeing" and provided the skills needed to make that belief real. Together, these have kept us returning to Farb's work for its authenticity of vision, which Champa was the first to recognize. Although a matter for speculation, we wonder to what extent Farb's "spiritual landscapes"—as Champa described them some years ago—would have taken shape the way they did were it not for his insistence on her ability to produce works of such unabashedly brazen beauty. Finally, we extend our gratitude to the artist herself. The power of her paintings has inspired both of us for at least two decades, and we are truly fortunate for the graciousness and enthusiasm with which she has helped bring this project into being.

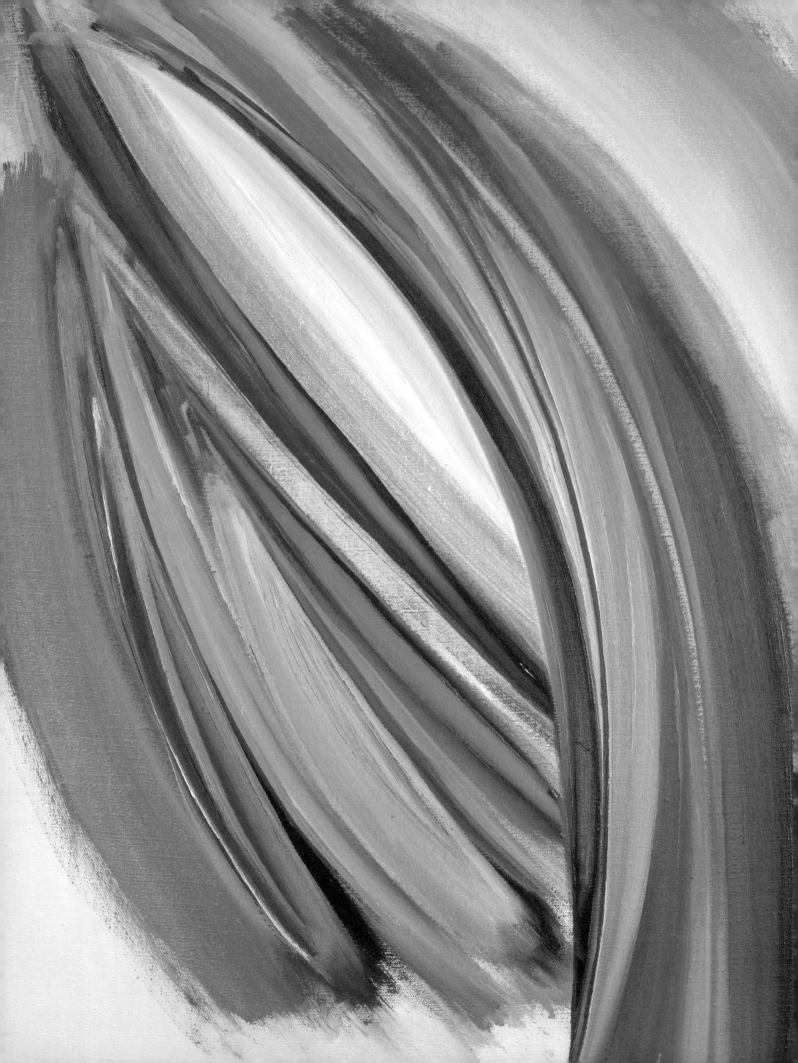

Fish, Please, But Make Mine on Canvas:
Some Thoughts on the Life of Adrienne Farb

Joanna E. Ziegler, College of the Holy Cross

> *"At the beginning, I am conscious of every step of the creating. The painting begins to have a presence and I have a dialogue with it, back and forth . . . Creating is often a very long, difficult and unpredictable fight. It takes time, patience, devotion, and passion. But at the end, the painting takes over and is present, in an almost overwhelming way. At that point, I almost can't bear to stop."*
>
> *Adrienne Farb, 2006*

When I proposed writing Adrienne Farb's biography for this catalogue, I had visions of sharing amusing tidbits, weaving them through many years of friendship (thirty now, to be precise), and having great sport picturing in print her agitated tenaciousness as a person. I would begin, I imagined, in Providence, at Brown University, and continue in Paris. Her friends and colleagues would often speculate about the wisdom of agreeing to let Adrienne cook a meal for us. Will she know, we wondered, the difference between the cans she's used for mixing turpentine and the one she's using to make the salad dressing? Will we be fatally poisoned by the worn-out fish that she had been painting constantly for the last several days and now might turn up *à la sauce meunière*? But she was so genuine, so eager to repay in whatever way she could for the support we provided her in the past. As it happened, a piece of fish (cooked promptly on leaving its position alongside the easel) was very special cuisine indeed in the tiny kitchen of her Paris studio. And who could refuse Adrienne such culinary joy, even if it did jeopardize one's intestinal integrity for a day or two? So we reassured her. It's all right, Adrienne, just paint. We're perfectly happy to savor your "taste" that way.[1]

Now, three decades later (and with Farb an accomplished cook!), looking back on her fish plates and paintings, it is, of course, the pictures I want to remember—where she was when trees or trout, mushrooms, zucchini flowers, or misty mornings filled her eyes. Oh yes, as her friend, I will always treasure those long-ago

The opening epigraph is from Adrienne Farb, response to the author's questionnaire, May 4, 2006.

[1] In an e-mail message to the author of July 23, 2006, Farb told a wonderful story about cooking for the painter Joan Mitchell, who remarked something to the effect of, "Thank goodness you are a very good painter, as you are a lousy cook."

meals amidst the bouquet of oil paint, but what I recall most of all is the sensual abandon of the colors encamped on canvasses that stood and leaned in every corner of the studio. It is her artistic legacy, not the culinary one, that matters most. Adrienne Farb was too busy painting—living and breathing it, even at times eating it, it seems—to learn, in those days, how to wield a pastry brush with the confidence and expressive subtlety of her paintbrush. And, then, our friendship went through many a change, events that are far more pertinent to an edgy, postmodern sort of biography than to the sort of narrative I believe her magnificent body of pictorial work so richly deserves.

What sort of biography should this be, then? In some ways, Adrienne makes writing it easy, for, if by biography we mean something having to do with writing a life, hers has been in painting, for painting, and about painting. Whatever personal matters stood in her way—and there have been more than a few, including real financial hardship, moves between countries and continents, and tragic losses—they turned into painting, as she turned to painting to disclose deeper pictorial realities than those aching realities of everyday life. Her painting and her life are inseparable. Inevitably, this biography is about both.

My purpose, then, is to reveal some sense of the force that birthed these living, dynamic, life- and light-filled images. This force is a human, whose "calling"—although we seem to avoid such quasi-religious terms these days, there really is no other way to name it—has been and continues to be to see the history of art in the literal light of nature. Paul Cézanne is reported to have said, in all likelihood apocryphally, that he wished to paint the works of Poussin over after nature.[2] I say, using an analogous narrative frame, that Adrienne Farb wants to paint art history over after nature. The results are neither imitative nor "realistic" in the sense of a naturalism as we commonly think of it. Her works are utterly and totally abstract, and yet she constantly calls forth the color, spatial, and sculptural elements of great figurative and naturalistic painting in the Western tradition to guide her eye as it probes the particularities of light and color in Paris, London, and New York. To write her story is also to write about those guides—who they are, where she met them, and when, and of course, most critically, why.

In the mid- to late-1970s, when Farb was an undergraduate at Brown, she ravenously absorbed art history from her professor Kermit Champa, critic and scholar of Modernism, who also gave Farb her only painting course in college. He encouraged her to be a painter, and that relationship, of mentor and pupil—later, critic and friend—continued until Champa's death in 2004.[3]

Champa was very much the serene formalist in those days, coolly sailing through Clement Greenberg's more pointed views on Modernism, especially those on the pictorial flatness of Claude Monet's or Camille Pissarro's brushwork and of Édouard Manet's intricately shal-

[2] The source of this quote is complex; see Richard Shiff, *Cézanne and the End of Impressionism* (Chicago: University of Chicago Press, 1984), pp. 175–184, esp. n. 31. Cézanne's concern was to "vivifier Poussin sur nature." Marcia Brennan, generously as always, helped with this reference.

[3] See this catalogue's bibliography for a list of Champa's writings on Farb.

Fish, Please, But Make Mine on Canvas

Fig. 1: *Crossed Paths Parc Montsouris, No. 1*, 1979. 46 x 55 cm (18 x 21 in.)

Cat. 1: *Luxembourg Rain*, 1980.

low space and bold, high-contrast drawing.

Farb heard a lot from her professor about the late-nineteenth-century pictorial vanguard of which these artists were at the heart, particularly as it made its way toward the breakthroughs in nonrepresentational painting achieved by Wassily Kandinsky and Piet Mondrian.[4] And she was able to see the real things while hearing Champa discuss them:

Le Repos, Manet's poignant portrait of his sister-in-law Berthe Morisot, is at the Rhode Island School of Design Museum of Art,[5] half a block from Brown's art department, while the Museum of Fine Arts, Boston, which Farb visited frequently, houses a world-class collection of Impressionist and late-nineteenth-century paintings. Champa's mapping out of these ideological and aesthetic strategies was comfortable for Farb, who was well acquainted from childhood with the stellar Impressionist works in her hometown museum, the Art Institute of Chicago. She says that, "Monet's *Haystacks*, at the Art Institute of Chicago, have always been important to me, from the earliest age The *Haystacks*, for me, are color as shape and color as atmosphere."[6]

In her early drawings and paintings, we sense the young artist working through this visual inheritance, developing it into her unique principles of observation. In an image such as *Crossed Paths Parc Montsouris, No. 1* (fig. 1) we see Manet's somber hues prevail within the overall high-contrast drawing, put on boldly, with plenty of impasto and eccentric marks and drips that call attention back, in almost a Cézannien way, to the originating planar surface. There is a vigorous optical contest between the dramatic X-shape that organizes the composition so very flatly and the fiercely sculptural modeling of the browns, grays, and whites that abut the drawing. This shuttling between two and three dimensions has close genealogical ties to the art history Farb learned at Brown and yet is a prescient statement of

[4] Champa (who had been my companion for many years at that time) was deepening his work on Mondrian then, which led him to write his *Mondrian Studies* (Chicago: University of Chicago Press, 1985).
[5] Curiously, Farb is related by marriage to Berthe Morisot's daughter's family; her husband's great-

great uncle was Henry Lerolle, an artist and collector who offered great support to many nineteenth-century artists. Henry's daughters, Christine and Yvonne Lerolle, were painted by Renoir, often depicted as the "Two Girls at the Piano."
[6] Adrienne Farb, e-mail message to the author, May 6, 2006.

Cat. 3: *Truite, No. 3*, 1987.

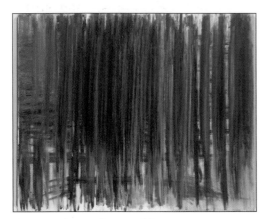

Cat. 7: *Luxembourg, No. 2*, 1989.

her particular artistic originality: at once learned and keenly aware of nature, she simultaneously transforms its particularities into a new, not-yet-experienced, purely pictorial world of space and color. We see this power in *Luxembourg Rain* (cat. 1), the earliest painting in the exhibition. There is the somberness of rain and the density of reflected pools of gray light, and yet everything is new and different. The hues, which are as much drawn as painted, envelop forms in a sculptural way; they are both outline and shape, a kind of paint-heavy seeing of the garden in rain.

It is fitting that this exhibition begins with Farb painting a fish—that wonderfully patient

trout—and the Luxembourg Garden, where she "obsessively drew and painted the *allées* of *marronniers*."[7] In *Truite, No. 3* (cat. 3) she seems rather suddenly to abandon her Manetlike mode of representation for a high degree of abstraction. She allows the vertical bands of color to dangle, firmly anchoring their roots to the top of the picture surface; their "natural" weight pulls them downward, where they droop, becoming mere shreds (or transparent scales) of thinly applied paint. Canvas, meanwhile, speaks as raw support and open-as-the-sea pictorial space. In *Luxembourg Night, No. 1* and *Luxembourg, No. 2* (cats. 6–7), we see emerging what will become a continuing preoccupation with vertical bands, and a passion for rhythmical repetition that has come to characterize her work ever since. Farb says, "For years I drew the trees in the Luxembourg Garden in Paris. These trees almost certainly began working themselves into my paintings as the vertical bands." Mondrian is present here, too, especially the nervous drawing that led him to create those weirdly cubist renderings of trees—the subject in nature that became for him (and, curiously, for Farb) the object of abstraction. As Farb recalls it, she "became an abstract painter in the Luxembourg Garden in Paris."[8]

In Paris, Farb had not yet experimented with the raucously inventive color we see in later years. While she admired the close-valued painting of the Impressionists, Manet, and the early Mondrian, her admiration curiously gave way to a far more fiery—dare we say hotter?—palette in London, where she moved with her new husband, Clément Bernard, in 1997.

[7] Ibid.
[8] Adrienne Farb, draft proposal to the American Academy in Rome, May 2006.

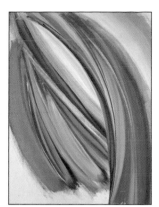

(Right) Cat. 8:
Funghi Porcini, No. 4,
1997.

(Below) Cat. 13: *Weather and Sky, No. 5*, 2000.

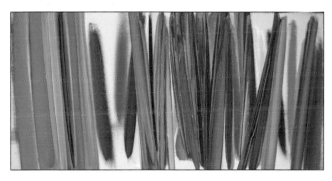

Funghi Porcini, No. 4 (cat. 8) (is the couple adjusting to the vegetarian offerings of the cooler British climate?) is a radical departure from the Paris pictures and shows Farb experimenting with an entirely new, far more sculptural quality in the vertical bands. In a single, massive, energetic gesture, she bends the bands back on themselves along a deep diagonal curve in space, creating a bowl-like opening within their curvilinear structure. Thus the entire picture seems to bend away from us, returning the ends of the bands back toward the picture plane—but not quite. There is a confidence here that shows Farb's emergent ability to speak her own controlled and distinctive visual language, and

that reveals her brilliant ability to generate intricate, fabulously colored spatial worlds within the picture plane.

For instance, looking at the *Weather and Sky* series is like watching a densely packed *corps de ballet* dancing on a shallow proscenium stage. It is an architectural scene, one that nearly lends itself to being perceived as a ground plan, in which the bands are distributed in much the same way we might distribute forms on the ground. In *Weather and Sky, No. 5* (cat. 13), the artist spreads the group out entirely across the picture plane, allowing her touch and opaque color—not to mention her highly selective use of impasto over and against areas of diluted, thin application—to invite some forms to step forward, almost outside our field of vision, and others to recede. The half-cylindrical, half-graphic forms are leaning and tilting and bending and touching, with one spongy, dark mark threatening to get free. Farb says, "I like to watch the forms unfolding in contemporary dance," and this series is real homage to that interest.[9]

And then there is the color, inseparable from the gesture that is in turn inseparable from the form. The artist explains it thus: "My paintings are about color. I want to invent almost indescribable color. In my paintings I try to create color intensities and nuances that go beyond nature. Color, form, and gesture become one."[10] Color seemed to intensify in her London works, with their scorching reds, oranges, and yellows bumping into each other, making loud coloristic noises. How very exuberant these pictures

[9] Farb (note 6).
[10] Adrienne Farb, e-mail message to the author, May 4, 2006.

are, displaying a particular energy that the painter abandoned for another as she entered the very different spatial and color worlds of New York, where she moved in 2001. The cold, gray light; her studio in Williamsburg, Brooklyn; the almost too-rich culture of the city; the terrifying days of September 11; the loss of Champa and, too soon after, her father; Farb worked through all of this in paint. I could go on about the rhythmic intensities that emerged first in close-valued explorations like *Petit Fiori di Zucca, No. 4* (cat. 16) or the ravishing *Those Cool September Mornings, No. 1* (cat. 19), which is rare for its unity of shape, value, and hue. Or the *Parmi les Éclairs* series (see cats. 23–25),

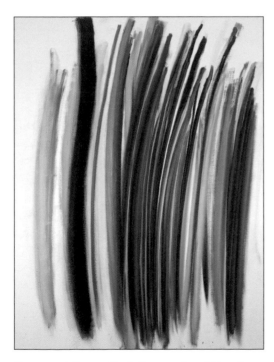

Cat. 19: *Those Cool September Mornings, No. 1*, 2003.

which sets us off at an angle, the space pushing hard toward our left, the energy working off-canvas, so much so that we feel compelled to turn our heads to follow it.

The pictures tell the real story. My goal here has in part been to set the stage, biographically, for a way to look at Farb's work—for a way to become more reverent toward a kind of painting that bears the hallmarks of the greatest traditions in the West and yet exists as something deliciously compelling all its own.

At the end of this catalogue, a chronology lists Farb's moves from Paris to London to New York while stating that she maintains her studio in Paris to this day. Yet Paris is more than one among equal cities; it is more than a place for the artist to revisit whenever she can, when once more she can absorb the light and the color of the sky and the lushness of the produce adorning the stalls and marketplaces; and it is more than a warehouse for her Paris pictures. With intimations that she herself grasps, Paris, for Farb, is the source of her pictorial ethics—the source, the wellspring, of how she lives in paint.

Indeed, Paris is where she became who she is as a painter, and where the truth of her painting took shape and where its natural identity, so to speak, emerged (see fig. 2). Farb terms this "abstraction," and elsewhere in this publication authors strive to articulate the character of Farb's distinctive abstraction, uniquely her own and certainly a form of abstraction that is more Modernist than contemporary. This is the most critical matter of the artist's life, and

getting at it is like learning about a culture in miniature. What is that culture? What is its language? What shaped its identity? I spoke earlier about Farb's voracious appetite for a kind of historical art, a visual hunger curiously at odds with her physical frame, ever so small and delicately fed. Whatever she creates in that world within the picture frame, Farb is seeing through her particular eye, which, we now know, developed in the light of art's history and in the natural essences of nature, and was driven by her singular expressivity.

Naturally, Farb's art-historical consciousness shifts its particular focus with time. For example, she was, in her words, "in awe of the [Donald] Judds" she saw recently in New York.[11] And yet, typically, there are paintings she returns to again and again. "Every time I see the same works I have known for years," she wrote me, "I see them differently. That's why I go to see them again and again. They speak to me in a multitude of ways based on my own life experiences and where I am in my work."[12] Thus Farb never wavers in her efforts to seek out historical art, to look closely at it, and look again. This is an important insight, for we see at work a fundamental practice that typifies her approach not only to apprehending the traditions she loves, but to working from nature and the world around her, and finally to creating the image within the picture frame. That practice has everything to do with repetition—and interestingly with, well, practice.

To a culture like ours, which values the new and the newfangled, and which hungers for

Fig. 2: *Adrienne Farb Painting Notre Dame, Paris*, 1988. Photograph by Joanna E. Ziegler.

change and difference in everything from the cars we drive to the cereal we eat and the spouses we choose, it should not be surprising that even the word repetition calls to mind dullness, sameness, and tedium. This attitude seems almost built into our perceptual lens, largely because today's technologies keep us fastened to a bewildering array of incessantly changing sounds and images. Although (or perhaps because) we are always at the ready for the next e-mail message, cell phone tone, or blog entry, our ability to contemplate an image for more than a nanosecond has been largely weakened. Thus it is not a criticism, but a sad reality that viewers often find Farb's work at first glance repetitious—all her paintings can seem pretty much the same, a few strands of usually vertical, wild color. If you've seen one, so this thinking might go, you have seen them all.

This is not a failure on anyone's part, for the audience beyond the gates of academe or outside the commercial art marketplace may reasonably ask: where in these paintings are the mushrooms, the zucchini flowers, the crisply aired September mornings? With their evocative specificity, Farb's titles seem to invite

[11] Ibid.
[12] Ibid.

viewers to see these very real-life things, no matter how transient or diaphanous they may be. And yet what they most likely see is a bunched grouping of highly colored, very abstract forms and shapes. While this is not the place for a lecture on abstraction, a few ideas may be of help.[13] As Christopher Dustin argues in one of the essays that follows, the abstract shape is a "living thing," but the real importance of abstraction lies in what he calls "the creative necessity" for the artist, not of reporting the visual facts of the observed world, which is what representational painters do, but of "drawing from life." Objects, as Dustin puts it, do not "drop out" of these pictures; rather, it is we who are drawn nearer their real presence, nearer to their essence, nearer to "what is living within them."

Farb's paintings, then, are more akin to music or dance than they are to painting as it is commonly perceived. Walter Pater, the late-nineteenth-century English literary and art critic, wrote brilliantly on this matter, arguing that all art should aspire to the condition of music, in which content is inseparable from form and sensation (the concept of "aesthetic emotion" that is now so totally estranged from our art critical discourse) derives not from the artist mimicking or imitating life but from the work of art's ability to embody the very "feeling" of life. This critical concept of musical emotion and aesthetic sensation *is* abstract and is one form of abstraction. Farb learned about this early on from Champa, whose own passionate fixation on music often brought him back to Pater's ideas. The love of music is a passion that Farb,

too, has lived, day in and day out, in her painting. After hearing Maurizio Pollini play Chopin and Liszt at Carnegie Hall in May 2006, she recounted, "While the linearity of music is very different from the immediacy of painting, these pieces . . . spoke directly to my work."[14]

To engage the "meaning" of this sort of painting (or the other nonmimetic arts of music and dance, for that matter) is to grasp its abstract content. And to do that, we must strive to acquire something of the skills and techniques of the artist: to search out a kind of loving and intimate ritual of seeing, again and again, and yet again. Should we wish to open the seemingly closed doors to abstraction—behind which lie riches bearing a promise of transforming our lives in ways that only the abstract arts can do—we must be open to certain things. The unfortunate but inescapable fact is that learning these things takes time and an occasion, and thus they remain far more inaccessible to most of us than does art with recognizable subject matter. For, in the realm of abstraction, there is a seeking out of a kind of "truth," and the way we reach that "truth" is by committing ourselves to a ritual engagement with the images, returning to them again and again, and yet again. When the pictures unfurl their aesthetic interiority of being, when we finally capture the prize for which they were made, that is because what they are and how they are made cohere. This is when form and content are impossible to consider separately; this is when making and seeing have become indivisible and for a priceless moment there is a lightning flash that illuminates the "meaning."

[13] I am currently collaborating with Christopher Dustin on a study of the art and philosophy of abstraction.

[14] Adrienne Farb, telephone conversation with the author, May 2006.

This, too, is what takes place in Farb's relationship with nature. The chestnut trees of the Luxembourg Garden are not merely pretty subjects Farb likes to visit. The gardens are a source, not just of inspiration but of light and color. The artist says, "I paint with the natural light. I particularly love the time of day when day merges into night, when concrete forms dissipate and the light diffuses contrast."[15] She doesn't make up the light in her head as some imaginary happening.[16] Light is real, as real as the chestnut tree that marks the special spot where she sits day in and day out in the garden. Farb often speaks about real places and how they felt physically and optically, and she is as specific in her pictorialization as she is in her conversation, conjuring up the foggy mist of London, the cool light of her New York studio, or the ravishing electricity of the clouds in Venice. These are the parts of nature we see everyday, too. But most people are not as attuned to this sort of nuance, to nature's delicate, deliberate, gradual changes. This sensitivity becomes almost instinctive to those of us who live by the water, where it sometimes seems as though we exist solely to bear witness to nature's essential rhythms of constancy and change, but above all to witness the performance of its unutterable and inexhaustible beauty. Like the ocean's waves or the sun rising over the bay, Farb's painting possesses just such an essential law—and asks us to approach it accordingly. This explains why Dustin claims that the artist is "not abstracting *from* life. She is abstracting *life*."

Farb's biography matters not because it furnishes an easy way of explaining her pictures but because her life has been about discovering and developing a love of certain practices.[17] As we have seen, these might include looking at the same paintings over and over; sitting by the same tree, patiently waiting for it to display its limbs as they twine themselves about the dying day or exhibit their stately bearing in the crisp, ever-so-cold morning sun; or marking and re-marking the bands of color. Place, then, really matters, for through place the artist makes specific the ongoing, changing interdependence of art history and nature, light and color, repetition and diversity. Place is *the place*, if you will, of Farb's pictorial culture. Wherever she lives and wherever she visits, she returns nearly obsessively to a single spot to behold and capture, to fix in time for *our* beholding, as only great artifice can do, the fleeting spirit of life.

[15] Farb (note 6).
[16] This approach is rather more consistent with contemporary art, which I define not as art being made now, but in terms of curatorial and commercial characteristics.
[17] I would like to thank my dear friend and aesthetic soul sister, Georgia Marsh (a superb artist herself!), for some of this phrasing and thinking on the matter of biography. Her brilliant drawing and painting—and utterly intelligent and philosophical whimsy about living life—keep me fresh and honest about many of the things I discuss here.

A Movable Feast: The Imperative of Place in Adrienne Farb's Abstract Painting

Charlotte Eyerman, St. Louis Art Museum

As an artist and a person, Adrienne Farb resists boundaries, classification, stasis. She was born and raised in Chicago, currently resides in New York, and came of age in Paris. Her visual imagination has also been nourished by international travels in Italy, Turkey, Egypt, Israel, and earlier in her life, Mexico, where she spent summers as a teenager. Farb's artistic iden tity poses complex questions: is she American? French? Franco-American? Looking at her passport does not resolve the conundrum. Rather, the answer lies in the balance—and the tension—between the poles of rootedness and transience, of being home and away.

On one hand, Adrienne embodies stability, given her tenacious commitment to her work, to abstract painting, to loved ones; on the other, she's all frenetic movement. My images of Adrienne, accumulated over twenty years of friendship, invariably evoke dynamism: moving through space, hauling paintings around the studio, transporting them on the Métro, lugging her giant shoulder bag—filled with sketchbooks and gouaches and paint brushes—around Paris or wherever she happens to be. I have rarely seen her without this bag on her shoulder or a paintbrush in her hand. If one were to portray Adrienne, like a modern day Saint Luke (patron saint of artists), this shoulder bag, her portable studio, would be the invariable icono-graphic attribute, like Saint Catherine's wheel or Saint Jerome's red hat. Not to lapse into hagiography, but the analogy to these single-minded saints is quite intentional. Adrienne's life is her work and her work is her life. These materials, the brushes, the gouaches, the oils, are as crucial to Adrienne's daily existence as the most functional pair of shoes. She does not leave home without them.

Where is home, precisely? Farb maintains two studios (one in New York—first in Brooklyn, now the South Bronx; and another in Paris that she has occupied since the mid-1980s). She resides—quite happily—in New York, after a stint in London. Her true artistic home, though, is France, not in terms of its literal borders, but in terms of its artistic traditions. Paris is at the center of Adrienne's development as an artist. But like so many Paris-based artists before her, from Nicholas Poussin in the seventeenth century to Édouard Manet in the nineteenth, Adrienne traveled to Italy to enhance her aesthetic experiences and references. I think of her travels there as her self-nominated "Prix de Roam," since she has not yet achieved an official award to travel in Italy, although I would argue that she should.[1]

Adrienne moved to Paris at the age of twenty-two. Armed with a magna cum laude in art

[1] The Prix de Rome was established by the French Academy in the seventeenth century as a fellowship opportunity for students studying at the École des Beaux-Arts.

history from Brown University, she set about the business of becoming a painter, an arduous career path in the best of circumstances. Farb's challenge was offset by receiving a fellowship from the American Center, Paris, that provided a studio there. However, she was, and is, a fundamentally independent artist, completely free of official sponsorship, formal academic artistic training, or institutional affiliation. Like legions of aspiring painters maverick in spirit or inclination, Farb plunged into Paris. Her art was shaped immediately and palpably by the city's rich urban texture. the Seine, the grand and intimate parks, the bustling markets and street life, the architecture, the human scale of the skyline, and of course, the light. While nature plays an immensely important role in Adrienne's work, culture is an equally powerful force. Paul Cézanne reportedly said that the Louvre was an unmatched book from which to study, but that nature was all. During her years in France, Adrienne absorbed both lessons. She is and always has been—an avid museumgoer, as well as an inveterate sketcher, indoors and out.

Artists respond to what they see and experience. Like the great French painters of the nineteenth century, Adrienne came to Paris as a seeker: ambitious, driven, literally hungry for all that the city had to offer. Her visual imagination, that complex repertoire of formal structures and chromatic inventiveness, was nour-

ished by Paris in all its lucidity and cosmopolitan energy. Adrienne's daily rituals embraced both ends of the spectrum, and her work, too, reconciles the antithetical relationship between calm and chaos. I have vivid memories of Adrienne navigating the anarchic, lane-oblivious public pools where she swam therapeutic laps. For transportation, she sought out the genteel above-ground experience of the bus— the number 95 in particular, as it descended from Montmartre, where her studio was located, and dropped her off at the Louvre. In addition to the poetic-sounding, deceptively romantic idea that we may have of Paris, living there can be challenging, especially given the painful reality of having few material resources.

Adrienne's "Frenchness," like that of Mary Cassatt, another American who ultimately became the painter she was because of her experience of traveling and living abroad, owes a great deal to the direct visual education that Paris provided.[2] While there is no literal connection between Cassatt's work and Farb's aside from a shared commitment to color, there is a shared openness to Paris, to France, and to French art, past and present.

I am reminded of Edgar Degas's image of Mary Cassatt and her sister visiting the Louvre, fashionably dressed but there to see rather than be seen.[3] However, the Cassatt painting that strikes me as the most Farbian is *In the Loge*

[2] Cassatt traveled elsewhere in Europe as well, but the Parisian experience was the most crucial to her artistic identity; see Judith A. Barter et al.,

Mary Cassatt: Modern Woman, exh. cat. (Chicago: Art Institute of Chicago, 1998).
[3] Illustrated in ibid., p. 108.

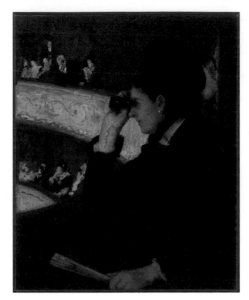

Fig. 1: Mary Stevenson Cassatt. *In the Loge*, 1878. Oil on canvas. 81.28 x 66.04 cm (32 x 26 in.). Museum of Fine Arts, Boston. The Hayden Collection—Charles Henry Hayden Fund. Photograph © 2006 Museum of Fine Arts, Boston.

(fig. 1). It looks nothing like a Farb painting, of course, but it captures the pure Parisian intensity that I associate with Adrienne, especially during the time I spent in Paris with her in 1986 and again in the early 1990s.[4] A woman alone, starkly dressed in black and intently, obsessively *looking* evokes Adrienne for me. Not that she could ever afford to go to the opera in those days, but Paris and its public spaces are (and have always been) a pageant of scopophilia. The whole culture of the place is about looking. Staring, even. It can be uncomfortable to be stared at, but it's naturally French to look, and "Voir à savoir" might be the country's official motto. For Adrienne, Paris provided a visual feast. While her looking is not about class and gender and social networks—it is about light and color and form Cassatt's painting of an intensely visually engaged woman is a kind of leitmotif for this mediation on Adrienne's art.

I make the link between Cassatt and Farb because as fundamentally "American-French" painters, they share an artistic identity. For example, I have observed that in museums, curators of American art always claim the Pennsylvania-born Cassatt as a prime and celebrated American artist, while curators of French art regard her as one of theirs. The latter camp (to which I belong) argues that Cassatt became the painter she did, an Impressionist, during her time in Paris and her association with her Impressionist cohorts, and Degas in particular.

While national identity may be defined by birthplace, artistic identity is shaped by myriad factors—formative experiences in childhood and young adulthood, education, and, of course, place. A hundred years after Mary Cassatt, Paris is where Farb literally came of age as an artist. Access to museums was a crucial ingredient in that process, especially given her somewhat oppositional status as a self-trained artist. No matter how terrible her living conditions may have been in those early years, the museum provided a reliable and welcoming—indeed nourishing—home. The Louvre, for instance, was free, warm in the winter, and relatively cool in the summer, offering a respite from the city as well as access to great treasures of Western art.

At the Louvre, the Jeu de Paume (the collection has since moved to the Musée d'Orsay), and the Orangerie, she engaged with works that fueled her pictorial imagination. Following the path paved by Eugène Delacroix, Gustave Courbet, Paul Cézanne, Édouard Manet, Claude

[4] Professor Ziegler facilitated the introduction, providing the phone number and encouragement to call. I met Adrienne in February 1986 while studying French and art history on a term abroad in France during my junior year at Holy Cross. As a student at the University of California at Berkeley, I lived in Paris from 1991 to 1994 to conduct doctoral research.
[5] It's important to note that in addition to her ersatz family of painters in the history of art,

Adrienne's biological family is also a family of artists, thinkers, creators. According to Farb, her father was a graphic designer and artist, her mother was a pianist, her uncle Misch Kohn was a printmaker, and uncle Harold Cohen is a designer and graphic artist; her great-aunt Ann Medalie was a painter who worked with Diego Rivera on a mural for the 1939 World's Fair in San Francisco; and her sister Jo Farb Hernandez is an independent curator of museum exhibitions.

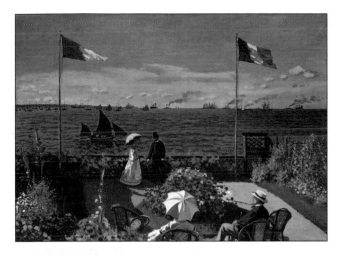

Fig. 2: Claude Monet, *Garden at Sainte-Adresse*, 1879. Oil on canvas. 98.1 x 129.9 cm (38 3/8 x 51 1/8 in.) Metropolitan Museum of Art, New York. Purchase, special contributions and funds given or bequeathed by friends of the Museum, 1967. Photograph © 1989 The Metropolitan Museum of Art.

Monet, Degas, Cassatt, and others, Adrienne spent long days, day after day, looking, drawing, pondering—hungrily devouring the living art history surrounding her. As a painter, Farb's language is color and form—inseparable in her practice—and her vocabulary is inflected by a deep saturation in the traditions of Western painting. Her touchstones, then and now (two of her great qualities, as an artist and as a person, are her tenacity and her loyalty), are the great masters. A measure of her openness, and her pictorial voraciousness, is the range of painters she regards as mentors. A visit to her studio was dually a visit to her postcard museum. Postcards were hung everywhere, like family photos, in the kitchen, the bathroom, the bedroom (which has a tub in it—a very nineteenth-century touch). [5]

When I asked Adrienne to identify a few important paintings for the purpose of this essay, the list was very long, but a discussion of a few signal works illuminates her relationship to the tradition. There are myriad nineteenth-century paintings in her personal pantheon, but she specified Monet's *Garden at Sainte-Adresse* (fig. 2). At first glance this seems quite far from a Farb painting, but if one imagines away the anecdotal figures, fashions, and flags, its attraction to Adrienne becomes clear. [6] Monet, master of apparent spontaneity and on-site observation, which Adrienne practices in her sketches, is also extremely invested in a gridlike structure that seems to anticipate the works of Piet Mondrian, and indeed, her own. In the Monet painting, nature, represented by the cultivated garden and the expansive sea, dictate the artist's compositional choices, but his color is pure invention.

This highly structured yet antimimetic strain of painting sustains Adrienne's decades-long project to make work that emphatically refutes our own culture's claims about the so-called "death of painting." [7] Given the vitality of Adrienne's work, her signature of chromatic vividness and compositional dynamism, it is not surprising that she would specify a slate of painters noted for color, technical bravura, and painterliness. The bigger surprise, as one considers Adrienne's pictorial education that unfolded over more than two decades in Paris, is the importance of the Old Masters at the Louvre, which has been at the heart of every artist's experience since that venerable institution became a public museum after the French Revolution.

[6] I invited Adrienne to speak to students in my "Nineteenth-Century European Art" course at Union College in 1998 and recall that her talk addressed this painting as a major touchstone.

[7] There is a growing and potentially enormous bibliography on this subject; for a good primer, see, Robert Storr, "Thick and Thin," roundtable discussion, *Artforum International* 41 (April 2003), pp. 174–179, 238, 240–241, and 244.

The Louvre offers so much more than the *Mona Lisa*, an icon in the history of art that has become a spectacle due to throngs of tourists who line up for hours, only to walk by the Plexiglas-encased painting while videotaping it. It is not the tourists' fault, of course, for the *Mona Lisa* has become, thanks to marketing and mass-reproduction (not to mention the recent blockbuster novel, *The Da Vinci Code*), nearly a parody of itself.[8] I mention the ambulatory "viewing" of the *Mona Lisa* to point out that Adrienne's way of being in the Louvre is anathema to it. For Farb, art, in terms of making it, thinking about it, and looking at it, is fundamentally about slowing down, stopping to look. Not for twenty seconds or for two hours, but looking for twenty years. Literally.

As dynamic as her compositions are, they are born of stillness, of meditation, reflection, and painstaking slowness. Part of that process is how she spends her time: looking and drawing in the museum, sketching outdoors *en plein air*, painting in her studio, and returning to the museum to repeat the cycle over and over again. There are paintings in the Louvre that Adrienne has been intimately engaged with, like old friends or lovers, for decades. It is the kind of relationship that Cézanne hinted at when presumably he said he wished to "revivify Poussin before nature." The Old Master feeds the ambition, and the complexity of vision, of the New.

For the serious, serial visitor to the Louvre (whether professional or amateur) there are certain favorites that one always goes to see. Works of art in museums are like old, reliable friends who (if on view) are always available for a rendezvous. Generations of artists gathered there: one recalls that Manet and Degas first met at the Louvre, in front of a Velázquez.[9] Indeed, one walks the halls of the Louvre with the keen awareness of who walked them before: from David, who had a studio in one of its attic garrets, to the Dutchman Piet Mondrian, whom one imagines absorbing the lessons of David's severe linearity when he lived there in the years before World War I, when Paris was the crucible of Cubism. Adrienne herself was drawn there almost immediately upon arrival in Paris. It is where she went to post-graduate art school.

The revelations in the Louvre are innumerable. I began to know them during my own student years in Paris and experienced them, on numerous occasions, in Adrienne's company. We would go at night, on Mondays and Wednesdays, because the crowds were few. For me, the "appointment" works have been fairly unchanged over two decades, but there are always epiphanies. For example, the monumental still life, *The Ray* (1728), by Jean-Baptiste-Siméon Chardin always makes me think about a painter's ability to pose complex philosophical questions about time and mortality and the essence of being by deploying apparently simple means: "just" paint on canvas; just fish and vegetables and utensils and an agitated cat. The result, however, is magical, mesmerizing. I feel the kinship between Adrienne's deceptively

[8] Walter Benjamin arguably predicted this in his seminal 1936 essay "The Work of Art in the Age of Mechanical Reproduction" republished in Walter Benjamin, *Illuminations: Essays and Reflections*, ed. Hannah Arendt (New York: Harcourt, Brace, and World, 1968), pp. 217–251. If here were here today, I would wager that Benjamin would be aghast that one can now read his entire essay (and access images at the Louvre) on the internet; on the subject of the novel and the subsequent film he would surely be speechless.

[9] See Gary Tinterow and Geneviève Lacambre et al., *Manet/Velázquez: The French Taste for Spanish Painting*, exh. cat. (New York: Metropolitan Museum of Art, 2003), p. 389.

straightforward paintings and certain Old Masters in the Louvre, precisely because the museum is the table where she dined, so to speak, for sustenance.

As an art lover, Adrienne's tastes are broad, inclusive, sometimes surprising. Given her profoundly visual nature, the eclecticism of Farb's favorite artists and works is not surprising. At the Louvre she seeks out, perhaps more than those of any other artist, the works of Raphael, the sixteenth-century Italian painter noted for his sensitive, emotionally resonant depictions of the Madonna and Child, as well as the gorgeous modulated light in his landscape backgrounds. Farb's Raphael of choice, the one she goes to see as if for an appointment or a reunion, is the portrait of the courtier Baldassare Castiglione, the "Renaissance Man" par excellence (fig. 3).

It is a sublime painting, not just for its evocation of one of Italy's greatest writers and intellectuals—the painting seems to breathe the very process of thinking—but also for its rich gray tonalities.

It is as much about the sensuousness of space as it as about a man, his mind, and his accoutrements. Considering this picture through the prism of Adrienne's admiration of it, I have contemplated why this cool, gray-and-black painting would appeal so much to her, given her intense love of color. What I have realized is that this nearly monochromatic work manages to wring color out of gray and black; it is about looking, thinking, and the power of spareness.

Even before she singled it out, I knew this picture was profoundly important to Adrienne, and whenever I see it, I think of her and am reminded that her love of Raphael hints at a much

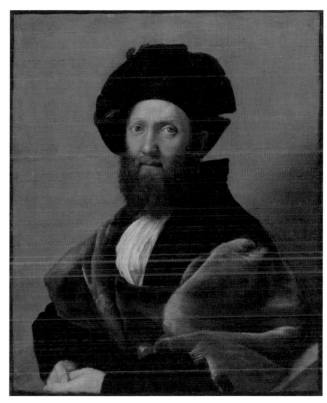

Fig. 3: Raffaello Sanzio, called Raphael. *Portrait of Baldassare Castiglione*, 1514/15. Oil on canvas. 82 x 67 cm (32 1/4 x 26 3/8 in.). Musée du Louvre, Paris. Photograph courtesy Réunion des Musées Nationaux/ Art Resource, NY.

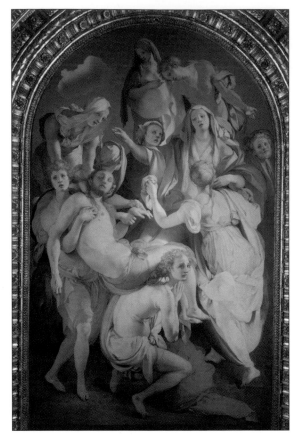

Fig. 4: Jacopo de Pontormo. *The Lamentation of Christ (The Deposition)*, 1525/28. Oil on wood. 313 x 192 cm (123 1/4 x 75 5/8 in.). Cappella Capponi, Santa Felicità, Florence. Photograph courtesy Scala/Art Resource, NY.

deeper connection to Italy. The Italian titles of some of the paintings in this exhibition do not specify her whereabouts or record her extensive travels to Florence, Rome, Umbria, Sicily, Venice, and so on. They are often very funny, however, and do hint at her playfulness, her wit, her love of food, and her Italophilia in general. She loves high-fashion shoes (though she collects them more often than wears them). I'm still waiting for her "Ferragamo" series of paintings.

Many years after we had both left Paris, we met again in Florence, where I invited Adrienne to

speak to my students when I was teaching a course on Italian Renaissance art.[10] Toward the end of the course we got to Pontormo, a next-generation contemporary of Raphael who couldn't be further from him in style or temperament. Indeed, it was a thrill to introduce Adrienne (as well as the students) to Pontormo's greatest work, the mysterious, powerful *Deposition* (fig. 4). In a city full of treasures, this painting, still *in situ* in the Church of Santa Felicità, is a marvel. In its rejection of reality, notably the laws of time and space, it is both mesmerizing and downright weird—it looks like nothing else painted at the time. When one looks at the Pontormo *Deposition*, Farb's painting comes to mind, particularly in terms of its shared penchant for dynamic forms and wild color—hot pink, vivid orange, and electric blue. Across five centuries, these two artists share a compositional approach that I would characterize as exuberantly choreographic.

By the time I brought Adrienne and my students together in front of the *Deposition*, she had made numerous sketches of the work. Whether or not the students realized or appreciated it, they enjoyed a rare privilege: witnessing first-hand the power of art to traverse time and culture. Adrienne "revivified" Pontormo (à la Cézanne before Poussin) and Pontormo animated Adrienne, in a kind of two-way dialogue of highly sophisticated, and thoroughly original, pictorial imaginations.

While Paris is at the center of my long association with Adrienne, it was during our time together in Italy that I gained an understanding

[10] Union College term abroad, "Italian Renaissance Art in Context, from Giotto to Bronzino," Spring 2000.

of how important place is in her work. There's something about Italy that releases her sense of artistic freedom, of possibility and experimentation. Time there is about experiencing, savoring, seeing. America was the land of her birth, Paris was home for nearly twenty-five years, Italy was respite; now that New York is home, both Paris and Italy offer escape from the routines of everyday life. In a way, Adrienne's Frenchness is highly intertwined with her Italophilia. There's a long-standing tradition of Paris-based artists going to study in Italy, thanks to the founding of the French Academy in Rome in the seventeenth century. Indeed, in the nineteenth-century Jean-Auguste-Dominique Ingres and Degas and Manet all passed through Italy on the way to becoming their artistic selves, building on the example of Poussin, their seventeenth-century forebear.

Though Adrienne's way of painting could not be further from that of Poussin, there are ways in which she follows in his footsteps, too. The artist's 1650 self-portrait, painted in Rome and currently at the Louvre, has a certain Farbian quality, in spirit at least. Poussin depicts himself literally surrounded by paintings. That portrait evokes for me an image of Adrienne's studio, for the paintings stacked five- or six-deep lean against every available wall. If she were to paint a self-portrait—and she is not so inclined—one imagines that she would depict herself surrounded by her materials. In fact, I would argue that her body of work *is* her self-portrait, an expression and extension of herself—physically, intellectually, spiritually.

No matter where she is, Adrienne experiences the world most fully by engaging it visually and through the creative process of making art.[11] During her trip to Florence in 2000 when we focused on the *Deposition*, Adrienne produced numerous sketches of the painting, as well as sketches after the city's architecture and its parks. As a memento of our time there together, she made a drawing for me of the Campanile, one view from her hotel room's terrace. Though she had seen it before, in this drawing the monument took on Pontormo-inflected oranges and pinks as a result of our Pontormo exercise with the students. The drawing complements another one she made in the Luxembourg Garden in the late 1990s, a wedding present that keeps Paris omnipresent in my own domestic life.

They both hang in my house now, not far from another gouache drawing of the Seine, my first purchase in 1986. This in turn speaks to a small fish still life (for which I knitted her a sweater in exchange in 1990, I think) and a treasured asparagus painting (1994), a gift that is extremely reminiscent of a painting that Manet gave to a client.[12] Of course Adrienne intended the Manet reference and I took it as such. The theme of exchange is important here because it is so deeply connected to Adrienne's long-term relationships with friends, with artists, with places. It was, needless to say, a habit of Impressionist painters to exchange paintings and to buy them from one another. I realized that Adrienne, in making that asparagus, was identifying with Manet—as she should. Like Manet, Farb is a painter's painter.

[11] Indeed, in our last telephone conversation on July 23, 2006, Adrienne reported that she had recently returned from Italy, where she "filled up her eyes" with so much looking, as if gorging on too much food. In culinary terms she's a fish-eating vegetarian, but the gustatory metaphors for her relationship to art make her a kind of "optical omnivore."

[12] Françoise Cachin and Charles S. Moffett et al., *Manet, 1832–1882*, exh. cat. (New York: Metropolitan Museum of Art, 1983), p. 450–451.

Process is all in her work: seeing, sketching on site, looking and searching, and then getting down to work, starting with a blank canvas. There is no literal or slavish "quoting" in Farb's painting—rather there is a process of distillation. Given the breadth of her sources—Raphael, Pontormo, Cézanne, Courbet, Manet, Monet, to name only a few—what she takes away is not literal but intrinsically felt. Through tradition, Adrienne reinvents it.

Farb has been making abstract paintings for over twenty-five years; and while those of the last two decades or so seem to share a consistent formal language, they are in fact quite diverse. Her subject is color, and painting itself. She works serially, a nineteenth-century approach explored by Courbet and later by Monet and Renoir, and transformed again in the hands of mid-century American painters like Jackson Pollock and Mark Rothko.[13] Each of Farb's abstract paintings, however, has its own logic, its own internal tensions and formal relationships. While some of her early works display an Arthur Dove–like geometric quality, they have consistently been about the invention of a pure and otherworldly kind of painterly expression. Although informed by a habitual practice of drawing *"en plein air, sur le motif"* on the banks of the Seine, in the Luxembourg Garden or the Parc Monceau, or in the studio painting small still lifes of sardines or asparagus procured at the local *marché*, Adrienne's use of color is anything but referential. A sustained engagement with nature of a decidedly urban sort, as well as with the mundane, is expressed in her sketchbooks and in her (perhaps Chardin-inspired) painted studies of fish and vegetables.

The content of the larger-scale work, while consistently abstract, is dramatically diverse. Some of the earlier paintings in this exhibition, particularly from the late 1980s, seem almost grid-like, with painted surfaces that evoke tightly woven textiles. Others seem to engage the landscape—evocatively and metaphorically, never literally—with vertical or diagonal bands that act like trees and are reminiscent of Monet's 1891 series depicting poplars along the Epte River. Farb's signature bands seem, deceptively, to be grand gestures of physicality, while in fact they are created from many different and discrete brushstrokes.

Adrienne's process of making a painting is extremely traditional even while her nonrepresentational imagery and her inventive use of color are not. Her materials are extremely fine, and literally dear. When in Paris, I have witnessed Adrienne jump over barriers and argue vociferously to gain access to an exhibition, and I have seen the contents of her kitchen holding little else than garlic and pasta, but never has she skimped on the primary sustenance of her artistic life: oil paint and canvas.

When at work, she uses very fine brushes and executes small, discrete strokes, building her compositions in a neo-Cézannian manner. It's counterintuitive, perhaps, because these great swaths and energetic bands of color that span the canvases of her pictures from top to bottom or side to side seem to be continuous, but they are constructed—painstakingly, methodically, stroke by stroke. Unlike the strokes used by Cézanne in his *Bathers* (fig. 5), however, Farb's brushstrokes do not read like facets or tessel-

[13] See Charlotte Eyerman, "Courbet's Legacy in the Twentieth-Century," in *Courbet and the Modern Landscape*, exh. cat. (Los Angeles: J. Paul Getty Museum, 2006), pp. 20–37.

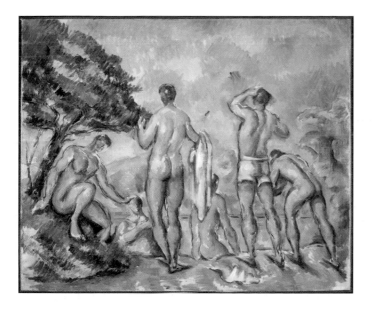

Fig. 5: Paul Cézanne. *Bathers*, 1890–92. Oil on canvas. 54.3 x 66 cm (21 3/8 x 26 in.). St. Louis Art Museum. Funds given by Mrs. Mark C. Stienberg. Photography courtesy St. Louis Art Museum.

lated pieces of a mosaic. The surfaces of her paintings are rich and painterly, the result of a highly meditative process.

Adrienne's paintings have always had a vibrating quality, whether the pulsing color and expansively spatial recent works or the tightly-woven, compact surfaces of the black-and-white and gray paintings, which act like chromatic sorbet, cleansing her palette. It is deceptive, though, to think of this vibrancy as connected to gesture, for even those works that seem to express the most physicality and convey the muscular idea of great swooshes of color are built from hundreds of small, considered strokes. Indeed, the dynamism of Farb's abstractions emerges from her sustained engagement with nonrepresentational marks, delicate applications of short, mostly vertical strokes that contribute to the creation of larger vertical, horizontal, and diagonal bands of color. The real frenetic energy of Farb's art resides in her mind—voraciously curious, searching, and wildly romantic, in the nineteenth-century sense of the term.

The complexity of Adrienne's painterly project of the past quarter century has to do with the heroic effort to work in a sustained, serious manner, day after day, week after week, year after year, in the solitude of the studio. Faced with the challenges of surviving as an artist (and for many years as a foreigner) in Paris, she has demonstrated a stubborn and completely admirable dedication to her work, and to abstraction as the *lingua franca* of her art.

She paints and has always painted with determination and steadfastness. But neither her work ethic nor her artistic philosophy has ever wavered. Her project is about invention, reinvention, and reinvigorating the seemingly familiar patterns of her painting practice. Each work is its own universe, even if it seems to be a variation on a theme. In many ways, her journey reveals the nuances of what we mean by "abstraction" in terms of its forms, vocabulary, and endless possibilities.

Certainly, the look of her paintings has changed in twenty-five years, in terms of her palette,

scale, compositions. She has moved on from Paris, to London, and then to New York. Significantly, this same trajectory was mapped by Mondrian, also an ex-pat and a ground breaking abstractionist with roots in the traditions of painting. Like Farb on her own path to abstraction, Mondrian made landscapes and still lifes, and was inspired by visits to the Louvre. His nonreferential grids, such as *Composition of Red and White: Nom I/Composition No. 4, 1938-42* (fig. 6) grew out of close observation of and engagement with the natural and the urban world. While seemingly far from pedestrian and quotidian concerns, the pure abstraction of both Mondrian and Farb would not be possible without them. All the chaos and energy of urban daily life is distilled into pure visual experience unburdened by narrative, anecdote, or iconography. For the viewer, meaning is made in the looking; for the artist, meaning is made in the processes of painting.

Adrienne Farb has never held a "day job," even though teaching gigs made it possible to pay the rent. She has never been part of a movement or a collective. She has resisted trendiness, gimmicks, and self-indulgent avant-gardism— so much so that her neotraditionalism makes her extremely innovative. Her only identity, standing alone and unwavering for decades, has been and is, "artist." There are compelling reasons to argue for her Frenchness, her Americanness, her internationalism. Home, for Adrienne, is "where the art is": the museum, the church, the ruin, the river, the park. If we look at her endeavor, the nation she truly belongs to is centuries old, multilingual, crosscultural: it is a utopia, a nation of painters.

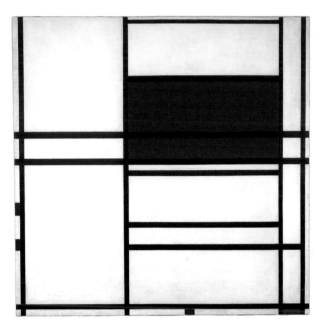

Fig. 6: Piet Mondrian. *Composition of Red and White: Nom I/Composition No. 4, 1938-42.* Oil on canvas. 100.3 x 99.1 cm (39 1/2 x 39 in.). Saint Louis Art Museum. © 2006 Mondrian/Holtzman Trust c/o HCR International, Warrenton, VA.

Intuition, Abstraction, and the Subject of Painting

Christopher A. Dustin, College of the Holy Cross

> *"Because the soul is progressive, it never quite repeats itself, but in every act attempts the production of a new and fairer whole."*
>
> Ralph Waldo Emerson, "Art" (1841)

Abstract and American

A renowned scholar and critic has described Adrienne Farb's paintings as operating "in an expressively emphatic world of their own—a world which, while in some respects unique . . . nonetheless remains anchored to canonically high modernism."[1] The idea that a painting, or the work of a particular painter, could stand by itself as a "new and fairer whole" and still be seen as anchored within a tradition might seem paradoxical at first. To the logical mind, originality and continuity, variety and regularity, spontaneity and design will appear as contradictory tendencies. But to the eye that finds itself *parmi les éclairs* (amidst the lightning)—one that immerses itself in the painting thus entitled—things will appear differently.

In a way, the tension between continuity and originality could be said to define the tradition with which Farb's work is associated. It does not take much critical argument to see her paintings in relation to those of the Abstract Expressionists (see fig. 1), whose obsession with making art that was in some sense utterly new had to be reconciled with the idea that they were all, in some sense, doing the same thing (and that, in so doing, they were still making art). In the present essay, I would like to pursue this observation—that Farb's work is abstract in the traditional Modernist sense—by relating it to another which is perhaps more surprising, given her biography: that, as the French critic and philosopher Yves Michaud has suggested, her work displays a sensibility that is "fundamentally that of American painting."[2] Together, these observations can offer guidance as we reflect on what Farb is doing, philosophically, when she paints. In thinking about what it means to paint abstractly, we shall also be thinking about what it means for us to see what there is to see here.

The opening epigraph is from the essay "Art," in *Essays: First Series*, originally published in 1841. The edition used here is *Essays and Lectures* (New York: Literary Classics of the United States, 1983), p. 431.

[1] Kermit Champa, *Adrienne Farb: Glimpse of the Moon*, exh. brochure (New York: Lohin-Geduld Gallery, 2004).
[2] Yves Michaud, "Flagrante présence," in *Adrienne Farb*, exh. cat. (Montbéliard: Centre Régional d'Art Contemporain, 1997), p. 8.

Art About Nothing?

In *After the End of Art*, Arthur Danto critically assesses the "aesthetic orthodoxy" of Modernist painting. In his view,

> Modernism . . . marks a point before which painters set about representing the world the way it presented itself, painting people and landscapes and historical events just as they would present themselves to the eye. With modernism, the conditions of representation themselves become central, so that art in a way becomes its own subject.[3]

Danto cites Clement Greenberg's landmark essay "Modernist Painting," in which Greenberg characterized the spirit of Modernism, in broad terms, as "the use of the characteristic methods of a discipline to criticize the discipline itself."[4] By an "immanent criticism," Greenberg argued, "each art had to determine," through its own operations, "the effects peculiar and exclusive to itself."[5] These effects were supposed to coincide with what is unique to the nature of its medium. The task therefore became, in Greenberg's words,

> To eliminate from the effects of each art any and every effect that might conceivably be borrowed from or by the medium of any other art. Thereby each art would be rendered "pure," and in its "purity" find the guarantee of its standards as well as its independence. "Purity" meant self-definition.[6]

Fig. 1: Willem De Kooning. *Untitled, XI*, 1975. Oil on canvas. 195.6 x 223.5 cm (77 x 88 in.). The Art Institute of Chicago. Through prior acquisitions of John J. Ireland and Joseph Winterbotham; Walter Aitken Endowment, 1983.792. Photograph © The Art Institute of Chicago.

In Greenberg's view, while "realistic, illusionist art had dissembled the medium, using art to conceal art," modernist painting *"used art to call attention to art"* by openly acknowledging the features that constitute the medium of painting itself.[7] What the "Old Masters" regarded as limitations (a flat, rectangularly bounded surface and the physical properties of paint) ought now to celebrated, for these defined the very essence of painting as such.

This meant, on Danto's reading, that the essential function of painting could no longer be to represent objects but to answer the question of "how painting is possible."[8] What had been primary throughout the history of painting since the fourteenth century—the imitation of "things," or of the appearances of things, and their corresponding representational features—now became secondary.[9]

[3] Arthur Danto, *After the End of Art: Contemporary Art and the Pale of History* (Princeton: Princeton University Press, 1997), p. 7.
[4] Clement Greenberg, "Modernist Painting," in *Clement Greenberg: The Collected Essays and Criticism*, ed. John O'Brian, vol. 4, *Modernism*

with a Vengeance: 1957–1969 (Chicago: University of Chicago Press, 1995), pp. 85–93.
[5] Ibid., p. 755.
[6] Ibid.
[7] Ibid., emphasis added.
[8] Danto (note 3), p. 7.
[9] Ibid., p. 8.

Intuition, Abstraction, and the Subject of Painting

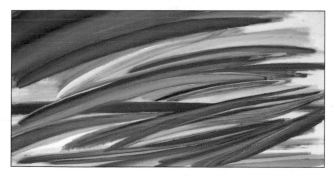

Cat. 12: *Weather and Sky, No. 2*, 2000.

It is important to note that this logic of self-criticism does not itself account for what Vasily Kandinsky described as "the striving toward the abstract"—a positive movement that leads not just away from the representation of recognizable objects but toward something else. Greenberg himself acknowledged that it was not simply by virtue of its exclusion of the figural "that painting had made itself abstract."[10] The grounds of abstraction must lie deeper than this.

The point is crucial, for despite his philosophically sensitive reading of Greenberg's narrative, Danto never uncovers the theory of abstraction that such a narrative might actually suggest. By failing to address the issue of what it means not just to paint as a Modernist, but to paint abstractly—by failing to address the question of what abstraction means—Danto supports a misreading (of Greenberg, I think, and of much Modernist art) that is commonly shared. Such misreadings tend to compromise our ability to see what there is to see in paintings like Farb's.

The misreading goes something like this. In their attempt to recover "the very essence of painting," the Abstract Expressionists not only acknowledged those features that constitute the medium, *they made the medium the very subject of their paintings*. Painting that is "pure," in Greenberg's sense, can be about nothing but itself. Whatever the title of an abstract painting may suggest—take Farb's *Weather and Sky, No. 2* (cat. 12)—there is really nothing for us to see here but colors and lines—forms without content. Such "formalism" is empty and lifeless, in this view. Because it excludes everything *but* pure form, there is nothing left for it to mean.

This is what Danto means when he says, "as the conditions of representation themselves become central . . . art in a way becomes its own subject." The Modernist spirit is "self-questioning," he writes, and "this in turn means that . . . the subject of painting [is] painting."[11] The material substance of art becomes the sole subject matter of art.[12] Danto asks, "was there anything internal to Abstract Expressionism that made it incapable of sustaining further progress?"

> One answer might have to do with the fact that, by contrast with the painting of the tradition, there was nothing for the abstract canvas to be but art. . . . It belonged in the collection, and hence, by contrast with [traditional] painting, was more and more *cut off from life*, and lived more and more a segregated existence. . . . The next generation of artists sought to bring art back in touch with reality, and with life.[13]

[10] Greenberg (note 4), p. 756.
[11] Danto (note 3), p. 67. In Danto's view, this "agenda" forced both artist and viewer to abandon an "aesthetics of meaning" in favor of a "materialist" aesthetics, the poverty of which led, in turn, to the end (or exhaustion) of Modernism.

[12] Ibid., p. 77.
[13] Ibid., p. 104, emphasis added.

The Subject of Painting

In *The Invention of Painting in America*, David Rosand tells a different story. At issue throughout the development of American art, he argues, are two questions, or sets of questions, which could not ultimately be separated: that of "identity" and that of "what and how to paint."[14] Rosand sees the issue of the medium as part of a larger dilemma that American artists inherited from their puritan past—that they were both susceptible to and deeply mistrustful of "the reality of the picture plane as a worked surface."[15] This combination of susceptibility and suspicion called the nature of painting itself into question. For American painters, who were especially anxious about relying on borrowed models, the issue of what it means to be a painting or a painter, of what is painted and how, became "an internal aesthetic dilemma that assumed ethical dimensions."[16]

What we ultimately see in Abstract Expressionism, Rosand argues, is no less evident in the art of John Singleton Copley or Thomas Cole:

> Responsive to the reality before them and seeking to reconstruct it on the painted surface, they transferred the initial intensity of looking into an intensity of making. Whatever they may have learned from masters or models, each encounter seems a fresh discovery; each rendering . . . has to invent, to discover its own means of imitation.[17]

This "primitivism," as Rosand understands it—the perennial rebirth of the medium, so that each painting is, as it were, the first painting, the original—was necessitated by the problem of identity, since what it meant to make an original image was precisely what was called into question. But then, the reinvention of the art of painting becomes, at the same time, a reinvention of the self:

> Each of our masters seems, in some fundamental way, to have discovered the rules of art on his own—and to have wondered at the discovery and that marvelous access to world beyond the picture plane. Each seems to have reinvented the art of painting—and implicitly, in all humility, himself.[18]

Humility is not a virtue one readily associates with Abstract Expressionists. Thus, when Barnett Newman says that the modern painter has to "start from scratch, to paint as if painting never existed before," it sounds like hubris.[19] But it is not self-assertion so much as self-questioning that Rosand associates with this process. Such painting was not "the answer" so much as a working or living through of the problem. Nor was it simply a matter of questioning conventional assumptions regarding the functions and operations of art.[20] For the functions and operations of art coincide with those of the artist, and it was these that needed to be worked out in and through the work the artist did. The artist's "principal problem is to discover what his true subject is," Robert Motherwell wrote,

[14] David Rosand, *The Invention of Painting in America* (New York: Columbia University Press, 2004), pp. xxiii–xxiv.
[15] Ibid., p. xxii.
[16] Ibid., p. 20.
[17] Ibid., p. 62.

[18] Danto (note 3), pp. 69–70.
[19] Barnett Newman, in *"Jackson Pollock: An Artist's Symposium," Art News* 66 (Apr. 1967), p. 29. Quoted in Rosand (note 14), p. 119.
[20] Danto (note 3), p. 119.

"and since painting is his thought's medium, the resolution must grow out of the process of painting itself."[21]

For Rosand, what modern American art is "about" is not just the means of making art. It is also about being an artist. Now, this might sound no less self-referential than Danto's formulation—as if every attempt at artistic expression were just a narcissistic gesture on the artist's part, the invention of a private pictorial language, or the celebration of "one's own voice." Rosand does talk about the Abstract Expressionists as creating different "iconographies of the self."[22] But this can be misleading, for they did not employ such languages to speak only about themselves. The problem the Abstract Expressionists were responding to was not just a biographical but a metaphysical one. To make an art of "one's own" is to discover the substance of one's self—or, in Motherwell's terms, what the "true subject" is.

In a letter written by Adolph Gottlieb, Barnett Newman, and Mark Rothko, responding to a critic who was befuddled by their work, the artists claim that "there is no such thing as good painting about nothing." Not that painting could or should be about just anything. The subject was "crucial," they asserted, but it had also to be "valid."[23] Why, then, was representation so problematic and the move to pictorial abstraction so necessary? Perhaps it was because "the validity of the subject" was seen as questionable, in all of its senses, all at once. First, there was the validity of the subject matter (Why paint this rather than that? Why paint anything at all?). Then there was the validity—the source or grounds—of the very activity of painting itself. Danto was right: art had become the subject, in a way. But he fails to appreciate in *what* way. For what is simultaneously at issue, in the art of abstraction, is the human subject, or self, and its "original" sources or grounds.

"The abstract shape," Newman later wrote in a letter, is itself "a living thing . . . real rather than a formal 'abstraction' of a visual fact, with its overtone of an already-known nature."[24] An "already-known nature," like the recognizable objects or "visual facts" that abstract painting supposedly abandons, is not to be wondered at. A "living thing" is. Newman says that the abstract form is not simply the shape *of* a living thing. It *is* such a thing. But then, it is no longer a "thing" in the objectively predetermined sense. One might rather say that, as a "subject," it is allowed to be what it is. And what is *that*? This is the question abstract painting raises from every direction at once. Painting that seems to make form its sole content is, in reality, making of itself a living thing together with the reality the painter paints. But then, artist and spectator are themselves implicated in this process: they too become "subjects" to be wondered at rather than the objectively determined beings we otherwise take them to be. This is the source of the mystery that often seems to surround abstract painting (and is easily mistaken for a kind of cognitive bafflement). For the matter it addresses *is* fundamentally mysterious.

[21] Robert Motherwell, "Painters' Objects," *Partisan Review,* (Winter 1944), p. 97. Quoted in Rosand (note 14), p. 159.
[22] See Rosand (note 12), p. 122.
[23] Repr. in John McCoubrey, *American Art, 1700–1960: Sources and Documents* (Englewood Cliffs, N.J.: Prentice-Hall, 1965), pp. 210–212. Quoted in ibid., pp. 129–130. The letter, signed by Gottlieb and Rothko but drafted in collaboration with Newman, was written in 1943 to Edward Alden Jewell, art critic for the *New York Times.*
[24] Repr. in *Barnett Newman: Selected Writings and Interviews* (New York: Knopf, 1990), pp. 107–108. Quoted in Rosand (note 14), p. 130.

Emerson, Intuition, and the Self

"Purity meant self-definition," according to Greenberg. "In making a painting," Rosand suggests, "the painter defines himself."[25] Jackson Pollock said that "any good artist paints what he is," but he prefaced this with the observation that "painting is self-discovery" (not the assertion of an "already-known nature").[26] How, then, does a painter paint what he is if he must discover what he is through that very process? Is the subject simply a matter of invention? Who or what "defines" what one is or how one pictures the world?

The problem Rosand identifies as fundamental to the development of American art is not less deeply rooted in the development of American thought. It was originally—and, I think, is still most powerfully—articulated by Ralph Waldo Emerson, whose essay on "Self-Reliance" is a profound meditation on "the validity of the subject" and what Emerson calls its "aboriginal" source or ground.[27] Just as Emerson is conventionally regarded as a prototypically "American" thinker, "Self-Reliance" is routinely viewed as a philosophical declaration of the American spirit of independence. But this essay, though well known, is, like Emerson's "Americanness," frequently misunderstood. Rather than simply calling on us, as autonomous individuals, to trust only ourselves—as if the self we could call our own were of a nature that was already known—Emerson confronts us with a question. I am called to trust, but then . . .

Who is the Trustee? What is the aboriginal Self, on which a universal reliance may be grounded? What is the nature and power of that science-baffling star . . . without calculable elements, which shoots a ray of beauty even into trivial and impure actions, if the least mark of independence appear?[28]

The question, for Emerson and for each of us, is whether the self (even the self that is self-made) is not just "made up," whether self-definition is not an ultimately arbitrary gesture. Here, as in art, the issue is one of originality, not just in the sense of uniqueness but in the sense that even the process of autonomous self-definition must draw upon something (a source, or origin) and is thus an act both of discovery and of making.

If the grounds of self-trust are so profoundly questionable, where and how could one hope to work out an answer? How are we to approach that "science-baffling star . . . without calculable elements"? Such an inquiry, Emerson writes,

> Leads us to that source, at once the essence of genius, of virtue, and of life, which we call Spontaneity or Instinct. We denote this primary wisdom as Intuition, whilst all later teachings are tuitions. In that deep force, the last fact behind which analysis cannot go, all things find their common origin. For, the

[25] Rosand (note 14), p. 169.

[26] Jackson Pollock, in Selden Rodman, *Conversations with Artists* (New York: Devin-Adair, 1957), p. 82. Quoted in ibid. p. 170.

[27] For an extended discussion of the relation of Emerson's ideas to Abstract Expressionism, see Christopher A. Dustin and Joanna E. Ziegler, *Practicing Mortality: Art, Philosophy, and Contemplative Seeing* (New York: Palgrave-Macmillan, 2005), chap. 10. For an interesting treatment of "Self-Reliance," see Lawrence Buell, *Emerson* (Cambridge: Harvard University Press, 2003), chap. 2.

[28] Ralph Waldo Emerson, "Self-Reliance," in *Emerson: Essays and Lectures* (New York: Literary Classics, 1983), p. 268.

sense of being which in calm hours arises, we know not how, in the soul, is not diverse from things . . . but one with them, and proceeds obviously from the same source whence their life and being also proceed.[29]

If we ask where our own originality stems from, "if we seek to pry into it," Emerson says, "all philosophy is at fault." "Intuition" is not a tool by means of which an intellectually abstract inquiry arrives at its conclusion. It *is* the conclusion of an inquiry that is not just theoretical but creative. Intuition, in Emerson's sense, is not a means of cognitive apprehension so much as a mode of vision. It *is* not just a way of answering the question "what am I?" It is the source of the self as a living subject rather than an object among diverse objects. "We first share the life by which things exist," Emerson writes, and "*afterwards* see them as appearances in nature," forgetting "that we have shared their cause."[30]

This "aboriginal" seeing is the work of intuition, as Emerson understands it—a form of awareness that is "personal" just insofar as it reaches beyond the self to participate in a source that is its own and yet precedes it. Intuition, then, is not a private hunch or a vague impression but a "taking in" that secures the validity of the subject by restoring it to that "deep force" wherein "all things find their common origin." The self that relies on intuition rather than living solely on the basis of "tuitions"—the received

teaching of recognizable and already-known objects—shall, Emerson says, both "live truly" and "see truly." Its productions shall be "wholly strange and new."[31]

Emersonian intuition, with its return to the "aboriginal" source, supplies the underlying imperative for Rosand's primitivism. The appeal to intuition does not, however, require the rejection of any and all models. One can paint intuitively, or one can paint "tuitively." One can also look at other paintings in either of these ways (Joanna Ziegler's remarks on Farb's practice of revisiting the works of other painters speaks directly to this). Emerson, like Thoreau, saw intuition as drawing ultimately upon nature, but not in a way so as to drive a wedge between it and culture. After all, it was not "wilderness" that Thoreau would recall us to as the source of our humanity, but "wildness."[32] Wilderness is an objective entity, a thing or place one can visit or paint, set apart by definition from other places or things. Wildness is, by contrast, more of an abstract quality, something one sees, or must look for, *within* the wilderness, and not just there but anywhere there is life. Wildness is not confined to wilderness. The latter is an external designation. The former, while not a "thing" in the objective sense, is more inwardly real because it is more essential: the very source of "what is living in nature," as Thoreau once put it. It is fuller and richer in meaning, more palpable to the senses, precisely because it cannot be seen or reported as a "visual fact."

[29] Ibid., p. 269.
[30] Ibid.
[31] Ibid., p. 271.

[32] "In Wildness," Thoreau says, "is the preservation of the world" (although he is often misquoted). And later, "Life consists with wildness . . . its presence refreshes [man]." Henry David Thoreau, *Walking* (Boston: Beacon Press, 1991), pp. 95, 97.

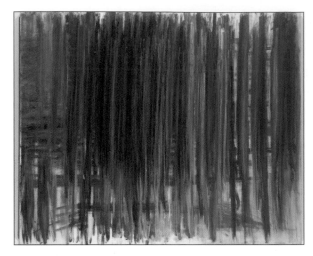

Cat. 7: *Luxembourg, No. 2*, 1989.

In Emersonian terms, one can have an eye for nature and still not penetrate to, or share in, its aboriginality. But then, an artist could remove herself from nature, as some-"thing" to be drawn, and still not remove herself from life as a source to be drawn upon. For Emerson, this may even be a creative necessity.

The Ends of Abstraction

So it was for Adrienne Farb, as I see her work. She has said that, for her, the act of painting is, from beginning to end, a matter of necessity: not simply a choice by the self but a choice *of* the self. Her means of achieving abstraction are intuitive, she explains, while the end or aim is to arrive at what is essential. But then, as Emerson suggests, the means *are* the end: intuition, as a source, is both the starting point and the conclusion (which is very different from saying that the medium is the subject matter).

About the fine artist, Emerson says that "the same power which sees through his eyes, is seen in that spectacle" which he paints.[33] Farb is such an artist. So it is that, while as a matter of biographical fact Farb has spent most of her creative life abroad, and while Joanna E. Ziegler has insightfully transcended a restrictive sense

of artistic provenance in suggesting that "Paris, for Farb, is the source... of 'how she lives' in paint," one might go still further in this direction and recognize that Farb is also, philosophically speaking, an "American" painter. She paints wildness, or the aboriginality of things. Her paintings are not of or about that. They *are* that. Her compositions are primitive, in Rosand's sense, but also highly refined and carefully crafted—preserving the "science-baffling" dialectics of spontaneity and design, continuity and difference, unity and plurality that constitute what is living in nature. There is balance and movement, incalculable yet ineluctable rhythm, and a kind of concealment that is more revelatory than full disclosure, as in *Luxembourg, No. 2* (cat. 7). This, a relatively early work, could be all too easily compared with one of Piet Mondrian's tree paintings—we may recognize, in both, some residual figural content (a landscape partially visible through a forested curtain). But then, we may overlook what is happening in either. In describing his own version of intuitive vision, Martin Heidegger speaks of "that which conceals in a way that opens to light . . . in whose clearing there shimmers that veil that covers what comes to presence of all truth and lets the veil appear as what veils."[34] It is, in fact, a forest clearing that Heidegger has in mind. But it is not the "visual fact" so much as the experience it occasions that he and Farb are striving to realize.

If we move from a painting like *Luxembourg, No. 2* to one that seems more fully abstract, such as *Petit Fiori di Zucca, No. 4* (cat. 16), as figural content or recognizable objects appear to drop out, do we see less, or do we see more? It would be truer, I think, to say that we have

[33] Ralph Waldo Emerson, "Art," in *Emerson: Essays and Lectures* (note 28), p. 431.

[34] Martin Heidegger, *The Question Concerning Technology and Other Essays* (New York: Harper and Row, 1977), p. 25.

Intuition, Abstraction, and the Subject of Painting

drawn nearer to that Emersonian "sense of being" which is "not diverse from things . . . but one with them." In Farb's work, unpredictable unities of color and structure, integrity "without calculable element," irregularities that resolve into something like absolute concord, have been taken in, or intuited, in such a way that, as "things" are seemingly taken away, we ourselves are taken back to that "same source whence their life and being also proceed." We have, in other words, drawn nearer to things in their pre-objective being and have perhaps come more fully into the presence of our own. We are not cut off from life, as Danto claims. We are, if anything, reminded of that "last fact" which is unanalyzable, and which, were it not for the art of abstraction, we should all too easily forget: that "we first share the life by which things exist" and only afterwards see them as appearances in nature.

"Nothing interests us which is stark and bounded," Emerson writes, "but only what streams with life. . . Beauty is the moment of transition, as if the form were just ready to flow into other forms."[35] Not all—perhaps none—of Farb's paintings are "nature" paintings in the traditional sense, and yet, in the philosophical or intuitive sense, I believe they are. They are certainly not "drawn from nature" in the way that phrase is conventionally understood. And yet, by joining us to that space "that connects instead of separating things" (this is Greenberg now), she paints in such a way that "art and nature confirm one another as never before."[36] If she does not "draw from nature," she does draw from life, and it is in this sense, I think, that her work is truly abstract. For this, I propose, is the real meaning of abstraction in art.

Cat. 16: *Petit Fiori di Zucca, No. 4*, 2002.

We usually conceive of mental or visual abstraction as a process of exclusion, a taking away or leaving out of the particular or accidental features of things. To conceive of it this way, however, is to miss the full meaning of the term. It comes from the Latin *abs-trahere*, which can mean "to take away" but can also mean to "draw from." In our understanding of this word, we tend to focus exclusively on what is left behind. But abstraction is a transitive verb: we do not merely abstract "from" things (abstraction is not *subtraction*). *Something is abstracted.* This can be seen as the result of a logical process, but painting suggests a different kind of derivation, more akin to reduction in cooking, where the full richness of multiple flavors is not only preserved but intensified, although the individual ingredients may be barely recognizable. There is no reason why we should not think about abstraction in such physical terms, for they may shed greater light on its metaphysical meaning. ("Painting seems to be to the eye," says Emerson, "what dancing is to the limbs."[37]) What abstraction means, in painting, is what Emerson means when he talks about drawing, intuitively, from an aboriginal source. This is what Adrienne Farb does. Her paintings do not show us what we see "afterwards." By withholding things as "appearances in nature," she shows us what is living in them. She is not just abstracting *from* life. She is abstracting *life*. This is what the "art" of abstraction ultimately consists in: the ability to draw life out of what one sees.

[35] Ralph Waldo Emerson, "Beauty," in *Emerson: Essays and Lectures* (note 28), pp. 1104–1105.
[36] See Clement Greenberg, "On the Role of Nature in Modernist Painting," in *Clement Greenberg, Art and Culture: Critical Essays* (Boston: Beacon Press, 1961), p. 173.
[37] Emerson, "Art," in *Emerson: Essays and Lectures* (note 33), p. 434.

Adrienne Farb and the Anti-Hip of Abstraction

Jay A. Clarke, Art Institute of Chicago

How can we, as general viewers, art historians, critics, or students living in a time when Conceptual art is all the rage, approach the work of Adrienne Farb, an artist overtly and at times vehemently indifferent to theorized conceptual frameworks? Although her more than twenty-year production of abstract drawing and painting could be read as a political gesture in and of itself, Farb does not keep current with recent theoretical approaches to art and feels no compunction to incorporate social or political ideas into her artist's statements. Instead, she claims, "my art training was not in art school, but I was 'trained' to simply learn how to look by an art historian . . . I try to make my own path and have an unswerving devotion to what I do."[1] The art "scene"—so much a part of what is "in" and "out" in the reception of and market for contemporary works—is far from her everyday experience, even if she visually devours works of art from the sixteenth through the twenty-first centuries in churches, galleries, and museums both in the United States and abroad. Similarly uninterested in subjecting her work to feminist interpretation, although painfully aware of the economic incongruities between male and female artists, Farb says, "I hope my work goes beyond that [gender] and is simply strong."[2] When asked how she reacts to the buzz around trends in the ever-changing contemporary art world, she states somewhat defensively,

"I want my paintings to be a kind of spiritual statement and to resist trends. In some ways that is very old-fashioned, I guess. I want my paintings to be seen as unattached to a specific moment. I want them to be timeless."[3]

Some might suggest that Farb's resistance to trends, her refusal to wrap a tantalizing Poststructuralist armature around her work to validate it, engenders the dangerous label "old-fashioned." But does it really? Could Farb's painting instead be considered post-Postmodern? The first reaction most viewers might have to *Weather and Sky, No. 3* (fig. 1) would be to fit it squarely into the rubric of gestural abstraction or color-based nonrepre-sentation. The forceful, almost harsh slashings of bright color that gather, overlap, and move toward the center while also moving away in a controlled, allover violence of staccato strokes may initially seem to be gestural. Historians and critics like Benjamin Buchloh, who favor critical theorists of the Frankfurt School, would understand Farb's manner of art making as a throwback to the 1950s and 1960s, a relic of emotive expression poured out, stained, or splattered onto canvases during the heyday of Abstract Expressionism, before painting was declared dead or at least at a dead end.[4] But Farb does not see her work as gestural or born of Abstract Expressionism.

[1] Adrienne Farb, interviewed by the author, May 2006.
[2] Ibid.
[3] Ibid.
[4] Amei Wallach, *"Driven to Abstraction,"* ARTNews 102 (2003), pp. 148–151. See also Douglas Crimp, "The End of Painting," repr. in *Abstract Art in the Late Twentieth Century*, ed. Frances Colpitt (Cambridge: Cambridge University Press, 2002), pp. 89–104.

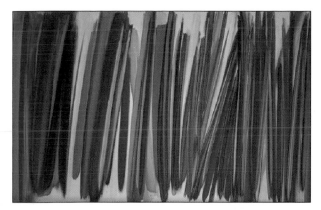

Fig. 1: *Weather and Sky, No. 3*, 2000. Oil on linen. 120 x 185 cm (47 x 73 in.). Courtesy of the artist.

Below, I will consider the historical baggage that Abstract Expressionism's dichotomous legacy has left us. But suffice it to say that most contemporary art historians and critics—save for those like Hilton Kramer on the far right—tend to fear an eternal return and thus avoid grappling with contemporary art that is abstract and decidedly, defiantly untheorized.[5] This is not to say that work such as Farb's cannot and should not be subject to rigorous and thorough theoretical debate; in fact, abstract art is now increasingly being tackled by a brave few.[6] But the general reluctance to deal with abstraction as a current practice has left a strange silence in both the market and the art press. The small minority of art stars working in what could be termed a gestural form of abstraction—and these include Brice Marden, Joan Mitchell, Gerhard Richter, and Cy Twombly—are notable exceptions. But how do they escape ridicule or just plain neglect?

Why should we care about Farb, an artist who has worked in varying degrees of abstraction since the 1980s? What does her work have to tell us? I am less concerned here with defending or theorizing abstraction, and in exhuming dead artists or critics as influences; instead, my goal is to understand an artist who has consistently approached abstract painting in a way that contemporary theorists now see as "dead." In Farb's case, abstraction is clearly alive and well and serves as an ever-increasing challenge to the viewer. In a way, it is a moot point whether abstract painting is once again viable and relevant, because for Farb it has always been so. Her work, however, does exist in a context, and it is this context I will explore.

Farb's work is self-consciously about space, color, pictorial tradition, the experience of extended looking, and—geographically, if not always politically—the place and time in which it was created. As the artist, critic, and author Jeremy Gilbert-Rolfe wryly and astutely remarked after seeing a show of Conceptual art in 1989, "one sort of looked in at the door and then thought about it later if one felt like it. That is not possible with non-representation, one can't 'get the idea' and then go home. The reemergence of non-representation means the end of the rule of the quick read."[7] This is certainly the case with Farb's work: it is no quick read.

I will explore Farb's painting in the context of abstraction today, as it relates to the indisputable legacy of Abstract Expressionism; in terms of its own internal space, color, and vision; and, lastly, through the historical models that the artist self-consciously embraces. At the same time, I'll be approaching her work from formal, theoretical, and geographic perspectives and from interviews with the artist.

[5] Hilton Kramer, "Does Abstract Art Have a Future?" *New Criterion* 21 (2002), pp. 9–12.
[6] See, for example, Frances Colpitt, "Systems of Opinion: Abstract Painting Since 1959," in Colpitt, ed. (note 4), pp. 153–203; Briony Fer, *On Abstract Art* (New Haven: Yale University Press, 1997); and Karen Wilkin, "Notes on Color Field Painting," in

Color Field Revisited: Paintings from the Albright-Knox Art Gallery (Milwaukee: Haggerty Museum of Art, Marquette University, 2004), pp. 15–30.
[7] Jeremy Gilbert-Rolfe, "The Current State of Nonrepresentation," repr. in Colpitt, ed. (note 4), p. 123.

Fig. 2: Brice Marden. *Study for the Muses (Hydra Version)*, 1991–97. Oil on canvas. 211 x 343 cm (83 x 135 in.). © 2006 Brice Marden/Artists Rights Society (ARS), New York. Photography courtesy Matthew Marks Gallery.

Together, this combination of looking and theorizing presents itself as a helpful means to grapple with the immense physical presence of Farb's work on the one hand, and its seeming absence of "hip" on the other. The late art historian Kermit Champa, the scholar who engaged most forcefully with Farb's work over the past two decades, described the consistently dependable visual charge of her paintings as "the excitement bred from the dedicated pursuit of sensuously original abstract form . . . the paintings need to be looked at with patience and intelligence."[8]

As mentioned earlier, there exist an "anointed few" artists today whose nonrepresentational, nonconceptual, nongeometric canvases are greatly admired and widely discussed. These include Brice Marden and Joan Mitchell, who are both roughly a generation older than Farb and briefly taught or visually mentored her. I use their paintings as examples of how abstraction has been recently received, because their production connects visually or philosophically with Farb's. As well, both work (or worked) for a sustained period of time within a tradition of gestural rather than geometric abstraction. Whereas geometry has carried the purportedly positive torch of conceptual theorization, ges-

ture has borne what is perceived to be the negative "baggage" of Abstract Expressionism. Marden and Mitchell have managed to negotiate the vicissitudes of time and fashion despite their enduring commitment to abstraction. While highly deserving of their success, one wonders how they manage to stay "in"—or in Mitchell's case, be posthumously pronounced "in"—when other deserving figures working in an emotive, interior, image-based manner are omitted from the ever-evolving canon.

Poised to create serpentine, curvilinear, and captivating works from his *Cold Mountain* series, Marden proclaimed in 1987, "abstraction is new, in its infancy."[9] Just three years prior, however, Buchloh leveled a biting critique at gestural abstraction, asserting that "exalted brushwork and heavy impasto paint application, high contrast colors and dark contours are still perceived as 'painterly' and 'expressive . . . through its repetition the physiognomy of this painterly gesture, so 'full of spontaneity,' becomes . . . an empty mechanics."[10] While Marden argues in a positive manner for the relative newness of abstraction, Buchloh denigrates as hollow its aim for expression through physicality.

To some extent this dichotomy remains in play twenty years later. Marden does not adhere to Poststructuralist rhetoric; instead, his work reveals certain degrees of art-historical influence, his practice of looking at and being inspired by nature, and his success at transforming visual, personal, and geographic experiences

[8] Kermit S. Champa, *Adrienne Farb*, exh. cat. (Paris: Galerie Zurcher, 1991), p. 3.
[9] As quoted in Colpitt (note 6), p. 153.

[10] As quoted in Colpitt (note 6), p. 162.

Adrienne Farb and the Anti-Hip of Abstraction

into tactile, linear matrices that dance on the canvas. In *Study for the Muses (Hydra Version)* (fig. 2), Marden defies the aspersions that Buchloh cast on high-contrast colors and painterly application, indulging in a daring use of vibrant reds on a yellow background, which he renders in a dense, if relatively flat, application of paint. In the *Hydra* series, the artist evoked the landscape surrounding his summer home in Greece, but the works are not *about* Greece. Likewise, in Farb's *Tuileries, No. 6* (cat. 5), the physical inspiration was the Tuileries Gardens in Paris, but the picture is not a representation of this site. For Farb, like Marden, work created in a particular city or environment is, as she says, "linked with the felt sensations of being in these places."[11] This is not to suggest that Farb's work is imitative of Marden's. Rather, in their desire to grasp the ungraspable spiritualism of nature, to capture in marks the metaphysical spatiality of a given canvas, they share similarities and gestures.[12]

Joan Mitchell also connects with Farb in very different ways—as a woman artist, as an American who adopted France as her home, and as a person who remained devoted to

Cat. 5: *Tuileries, No. 6*, 1988.

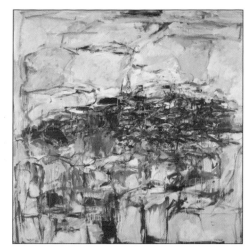

Fig. 3: Joan Mitchell. *City Landscape*, 1955. Oil on canvas. 201.9 x 201.9 cm (79 1/2 x 79 1/2 in.). The Art Institute of Chicago. Gift of the Society for Contemporary Art, 1958.193. © The Estate of Joan Mitchell. Photograph © The Art Institute of Chicago.

nonrepresentational painting her entire career. The two knew one another in Paris, and while they admired each other's paintings, Farb was not necessarily a fan of Mitchell's trademark hostility. However, her obsessive dedication to her work served as an important model for Farb, who recalls that while "she didn't influence my painting per se . . . seeing how passionate she was toward her painting was encouraging to me. For whatever her personal difficulties, she was deeply involved in her work and a very good painter."[13]

Mitchell's canvases were not painted outside; rather, she reconfigured her perceptions of nature and the city in the studio, creating what she called "abstract landscapes" from an emotional arsenal that Linda Nochlin has referred to as "a rage to paint."[14] Mitchell's *City Landscape* (fig. 3) represents the fury and energy of Manhattan, where she kept a studio at precisely the moment that her career took off.

[11] Farb-Clarke interview (note 1).
[12] For a discussion of Marden's relation to place and the metaphysics of space, see Madeleine Grynsztejn, *About Place: Recent Art of the Americas* (Chicago: Art Institute of Chicago, 1995), pp. 36–37; and Branda Richardson, "Brice Marden: Lifelines," in *Abstraction/Gesture/Ecriture*

(Zurich: Scalo, 1999), pp. 85–103.
[13] Adrienne Farb, e-mail message to the author, June 2006.
[14] Linda Nochlin, "Joan Mitchell: A Rage to Paint," in *The Paintings of Joan Mitchell*, exh. cat. (New York: Whitney Museum of American Art, 2002), pp. 49–59.

Cat. 23: *Parmi les Éclairs, No. 1*, 2005.

The dripped, painted, smudged color on the vaguely rectilinear, beige-and-white background maintains a structure and centrality despite its seemingly frenzied application. The forms fuse and coalesce in the center while remaining anchored to the ground below and connected to the sky above.

Farb's own comments on the "act of painting" as a "necessity, a drive, an urgency" correspond in many ways to those of Mitchell. Also, her New York canvases such as *Parmi Les Éclairs, No. 1* (cat. 23) contain an electric charge not evident in her earlier work executed in Paris or London. The canvas pulsates with surging movement toward the center, where the brushstrokes become thinner and more intensely connected; the rhythmic cadences of the thicker and thinner bands are intermingled as they move out to the far left and right edges. The commingling of finished and rough bands of coalesced yet independent marks echoes the artist's experience of urban life. Farb has commented on this, saying, "I find it visually exciting to live in cities. I like the diversity of faces, of rhythms, of lights and stimulation. The constant newness of situations, the unexpected."[15] On the specificity and electricity of her New York visual experiences, she has remarked on the "dramatic heights, the frenzy, the chance encounters, the feeling of freedom" that energize her work.[16]

The canvases of Marden and Mitchell, so different and yet so similar in their desire to capture a given moment or experience with aggressive and lyrical mark making, are certainly abstract works that have been granted the art market's highest approbation. However, these artists' contemporaries, including Gerhard Richter and Robert Ryman, have been received as more rigorously and theoretically "serious" due to their professed engagements with conceptual frameworks and the positive reception of their work by Poststructuralist critics. Conversely, Marden and Mitchell's paintings have been discussed in formal, geographic, and influential terms (Marden's work was shaped by Chinese calligraphy and poetry and Mitchell's by that of Willem De Kooning). But their reception has been spared from limiting formalist categorization due to their early, respective engagements with Minimalism and feminism, which provide a current theoretical framework in which to situate their production. Moreover, their work commands exceedingly high prices at auction—Marden's *10 (Dialogue 2)* (1987–88) recently sold for 2.4 million dollars and Mitchell's *King of Spades* (1956) for 2.9 million—and is the subject of monographic exhibitions at prestigious museums.

So how, then, do Marden and Mitchell remain above being censured as "old-fashioned"? And why, if their work is so readily embraced, are other abstract artists of equal caliber denigrated

[15] Adrienne Farb, interviewed by Joanna E. Ziegler, May 2006.

[16] Farb-Clarke interview (note 1).

as passé and marginalized for their painterly facture and expressive intent? Part of the answer is the collusion between the market and the museum world that helps to form an artist's reputation, and part is the slow and certain death of Abstract Expressionism. Pure abstraction—that is to say, abstraction without a theorized underpinning—is considered passé, a relic of a patriarchal, postwar past.

While this is not the place to offer a historiography of Abstract Expressionism since the 1950s, a brief look back is in order given the movement's connection to Farb's work.[17] Three figures, more than any others, molded the debate over Abstract Expressionism in its infancy and second generation: Alfred H. Barr, the founding director of New York's Museum of Modern Art, and the art critics Harold Rosenberg and Clement Greenberg. In his 1936 *Cubism and Abstract Art*, Barr set irrational, curvilinear, and romantic abstraction into a dialectical relationship with structural, geometric, and intellectual abstraction.[18] His definition of these terms through his eponymous, groundbreaking exhibition at MoMA was adapted and modified by Greenberg, who praised what he described as a new and distinctly American art form—Abstract Expressionism. As Briony Fer has noted, Greenberg altered the universalist reading that announced abstraction's metaphysical purity, focusing instead on a close formal reading of pictorial space. Greenberg first championed the art of Willem De Kooning and Jackson Pollock, and later that of Barnett Newman, Mark Rothko, and Clyfford Still. By contrast, Rosenberg was not interested in pure formal analysis, celebrating paintings that strove "not to a conscious philosophical or social ideal, but what is basically an individual, sensual, psychic and intellectual effort to live actively in the present."[19] Whereas Greenberg focused on opticality, Rosenberg judged a work by its freedom of process.[20]

In more recent years both Greenberg and Rosenberg's views have been taken to task as formalism has slowly but surely disintegrated. Especially the work of Greenberg and his protégée Michael Fried, which are regarded today as patriarchal, formalist interpretations, have been rightly deflated by feminist, Freudian, Marxist, and Poststructuralist scholars seeking more nuanced approaches to the art of the American postwar period. Writers of the last two decades, including Michel Leja and Marcia Brennan, have developed thorough and thoughtful revisionist histories of the first and second generation Abstract Expressionists, ones that include a wide range of methodological approaches.[21] These efforts, however, have left scholars with a trenchant historiographic connection between Greenberg's formalist aesthetics, the patriarchal and materialist society of the 1950s, and the mechanics of Abstract Expressionism.

[17] For a thorough historiography of Abstract Expressionism, see Ellen G. Landau, "Abstract Expressionism: Changing Methodologies for Interpreting Meaning," in *Reading Abstract Expressionism: Context and Critique*, ed. Ellen G. Landau (New Haven: Yale University Press, 2005), pp. 1–121.
[18] Wayne R. Dynes, *Turning the Corner: Abstraction at the End of the Twentieth Century* (New

York: Hunter College of the City University of New York, 1997), pp. 5–6.
[19] Landau (note 17), p. 14.
[20] Ibid., p. 17.
[21] See Michael Leja, *Reframing Abstract Expressionism: Subjectivity and Painting in the 1940s* (New Haven: Yale University Press, 1993); and Marcia Brennan, *Modernism's Masculine Subjects* (Cambridge, Mass.: MIT Press, 2004).

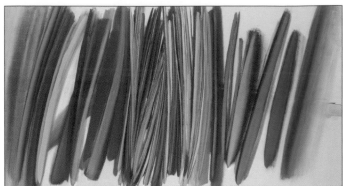

Cat. 15: *Bouquet Final, No. 2*, 2001–02.

In other words, the social, political, and gendered limitations of Greenberg's critical approach have been mapped onto the mode of abstraction itself. The negative characteristics of, for example, De Kooning's women, Pollock's ejaculations, and Lee Krasner's critical marginalization as a woman have cast a shadow over those practitioners following in the Abstract Expressionist's footsteps, regardless of their political leanings.

So how can Adrienne Farb's painting be understood as related to yet distinct from Abstract Expressionism or its contemporary progeny, including Richter and Marden? How does she conceive of her creative process and how does the viewer grasp it? Farb's painting, in her own words, manifests the visual experience, intensified, condensed, and intuited through color, space, and physical interaction. "My paintings are about color, I want to invent almost indescribable color. I try to create color intensities and nuances that go beyond nature. Color, form, and gesture become one."[22] The artist creates pictorial spaces that are very much dependant on subtle shifts and degrees of color and on her complex and unusual relationship to spatial depth. "I want the viewer," she says, "to experience a new kind of space, created by color."[23] These spaces exist differently in each work and yet are intimately related from one canvas to the next. In works such as *Weather and Sky, No. 3* (fig. 1), bands of color dance across the canvas, gathering together in four or five related clusters. They read right to left and back again, hopping and jumping across the picture plane. The dense blue that anchors the left side

of the canvas does not tilt the work but balances the other taut, hectic forms. Left of center, greens and yellows calm the surface. Narrow strips coalesce in the middle and at the far right; colored in intense, concentrated red, yellows, blues, and green, they nearly leap off the canvas. The connections and disconnections of color bring the work alive and provide their own inner logic. There is no volumetric space in this painting. The depth, width, length, and hue of the various bands and their curved, straight, feathered, or blunt edges create movement across, but not necessarily into, the flat surface.

Part of this lack of depth comes from the (perhaps fortuitous) limitations of Farb's eyesight: she lacks binocular vision, the ability to use both eyes together. Binocular vision allows for stereopsis, in which the two eyes' slightly different positions give precise depth perception and a sense of distance to a particular object. Farb is unable to see volumetric space, and therefore has no sense of "real" space. When pressed, she postulates, "maybe that is what pushed me to fabricate my own pictorial space that comes into being bit by bit but remains flat. Surface, therefore, is of more natural concern for me than volumetric space, which I have never seen."[24] This is exemplified in paintings such as *Bou-*

[22] Farb-Ziegler interview (note 15).
[23] Farb-Clarke interview (note 1).

[24] Ibid.

quet *Final, No. 2* (cat. 15), done in response to the September 11 attacks on the World Trade Center, which the artist witnessed from her studio. In this harsh canvas, the dense, intensely contrasting columnar forms at center are balanced by the pressing, expanding ones to their left and right. A subtle blue transects the picture from right to left in a roughly horizontal form. And yet there is no space or three-dimensional depth to the canvas. It is not about capturing a particular moment or view but rather about the experience of seeing and experiencing something, in this case 9/11, and manifesting this experience visually, in paint.

For Farb, the process of painting is less about gesture and movement than about the act of looking. This is perhaps related to her education. As she explains: "My art training was not in art school, but I was 'trained' to simply learn how to look by an art historian, and I have spent years looking in museums."[25] Interestingly, as an art history major at Brown University, Farb never took a class on Abstract Expressionism or twentieth-century painting and sculpture. Just prior to her undergraduate study under Professor Champa, however, he was writing criticism on the art of the second-generation Abstract Expressionists Helen Frankenthaler, Jules Olitski, and Larry Poons, and owned works by the last two.[26]

The act of intense looking, a desire to create an entirely new and spiritual space for the viewer, and an unpremeditated genesis is decidedly reminiscent of the stated goals of artists like Baziotes, Motherwell, Pollock, and Rothko. As

Farb recently revealed, "My painting has evolved slowly, with no sense of premeditation or strategy. It develops almost organically, incrementally. My painting builds on itself. I try to solve different problems in terms of space and color and atmosphere and want each painting to be a new visual experience. . . . I do not have a vision of how the painting will finish when I am painting."[27] The stated approach of many Abstract Expressionist painters in terms of the "unpredictability" of their process (Baziotes), its immediate, unmediated spontaneity (Motherwell), the canvas having an unpremeditated, internal existence all its own (Pollock)—not to mention their spiritual drive to create—is uncannily similar to Farb's, and yet when asked, she claims not to have been directly influenced by them:

> I see my work as more reflective than gestural. Of course the freedom of gesture and sense of abandon is part of my work, and my work is more intuitive than carefully planned and intellectual. . . . However I think my painting vocabulary is more focused, less expressive than what one associates with Abstract Expressionism. . . . The physical act of painting, the rawness and passion, is certainly part of my work, but I want my work to use that but go beyond that, to enter into a spiritual realm also.[28]

Reading statements such as these, we might ask whether Farb willfully ignores the painfully obvious connection between Abstract Expressionist practitioners' words, images, and

[25] Ibid.

[26] For a complete bibliography of Champa's publications, see *Seeing and Beyond: Essays on Eighteenth- to Twenty-First Century Art in Honor of Kermit S. Champa*, eds. Deborah J. Johnson and

David Ogawa (New York: Peter Lang, 2005).

[27] Farb-Clarke interview (note 1).

[28] Adrienne Farb, e-mail message to the author, June 2006.

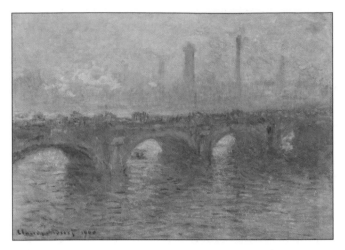

Fig. 4: Claude Monet. *Waterloo Bridge, Grey Weather*, 1900. Oil on canvas. 65.4 x 92.6 cm (25 3/4 x 36 1/2 in.). The Art Institute of Chicago. Gift of Mrs. Mortimer B. Harris, 1984.1173. Photograph © The Art Institute of Chicago.

intentions and her own, or whether she has simply internalized them to such a degree that they are not even conscious.

(We may also wonder why she has not picked up on the much-debunked myth of the "artist genius" who creates through pure, unmediated expression, as if guided by an outside force). She says, "most of my feelings about Abstract Expressionism come from looking, more so than reading."[29] Is it an unconscious desire to expunge a heritage or a true act of moving beyond what is self-evident? One way to question this lack of obvious influences would be to consider whom Farb does actively consider her artistic predecessors.

Understanding Farb's influences, which run from Fra Angelico and Raphael to Courbet and Rothko (the names change frequently), is not about source hunting. Indeed, in comparing her works to equivalents by other artists we can only go so far, and it makes more sense to investigate her descriptions of these connections as visual metaphors that help us to understand

how the artist sees the world and produces her work. As she eloquently put it, "artistic influences are certainly there in my work, but I hope not to be hindered by them. For me they are old friends with whom I have a continual conversation."[30] In other words, they speak to the artist and support her in her work as would an "old friend" but do not get in her way.

An artist of lasting importance for Farb is Claude Monet. Monet's *Grainstacks* series in the Art Institute of Chicago, her hometown museum, she said, "accompanied her through her childhood,"[31] and his other works have served as touchstones in subsequent homes; *Le Pavé de Chailly* (1865) and the *Waterlilies* in the Orangerie in Paris, and *Four Trees (Poplars)* (1891) and *Garden at Sainte-Adresse* (1867) at the Metropolitan Museum of Art in New York. Particularly insightful on her ongoing relationship with Monet are the remarks Farb made for an article entitled "Monet Viewed by Fifteen Contemporary Artists," in which she attempted to dispel the myth of Monet's "prettiness." Instead, she focused on his "dirty colors" that often "relate badly" and on the fact that he "brutalizes our preconceptions" by painting the most ephemeral elements of water and smoke "with maximum materiality." Here she refers to a picture from Monet's *Waterloo* series, one similar to the Art Institute's *Waterloo Bridge, Grey Weather* (fig. 4), in which pollution, fog, and mist intermingle. Farb speaks about the viewer's perception: "Our first approach to the painting is pushed into a flat universe: the bridge and chimneys of the factory prevent us from gaining access to any depth. Fixated to the surface of the water, we

[29] Ibid.
[30] Farb-Clarke interview (note 1).

[31] Ibid.

Adrienne Farb and the Anti-Hip of Abstraction

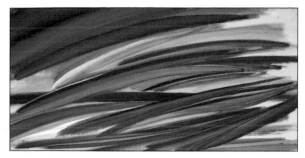

Cat. 12: *Weather and Sky, No. 2,* 2000.

Cat. 13: *Weather and Sky, No. 5,* 2000.

are immersed in the colors."[32] She also reveals that, unlike Monet, when she sketches *sur le motif,* she later erases these visions, keeping only the color sensations. Monet's lack of spatial depth; his use of nondescriptive, jarring, often inchoate colors; and his desire to capture a sensation rather than describe it all connect in obvious ways to Farb's approach to color and space. The notion of pictorial elements hovering on the surface, celebrating only the power of their color synthesis or clash, characterizes both Farb's work and particularly that of Monet in his later career.

Although Farb has not commented on it, another similarity between the two painters is their practice of working in series. For example, the paintings in Farb's *Weather and Sky* (2000) series, represented in this exhibition by three works, do not relate to one another in obvious ways. *Weather and Sky, No. 2* (cat. 12) is a rare horizontal picture with violent, vibrant colors that surge like racehorses toward the right of the canvas. *Weather and Sky, No. 5* (cat. 13) is more subdued in its color palette, with three discrete groupings of bands that move quietly across the picture plane. *Weather and Sky, No. 6* (cat. 14) is rendered in both wide and thin strokes, some densely painted and others thinned significantly with turpentine to create a bold wash effect. When asked how the titles of her series relate to the works within them, Farb explains, "I don't want titles to be descrip-

tive of place but more about the sensations of feeling brought on by the place or the pure joy of discovering something new . . . I give the titles when I feel I have reached the end of a certain path of challenges I set out for myself . . . and move on to the next 'period.'"[33] Although Monet's series titles are more obviously descriptive, they also demarcate a specific set of challenges the artist set for himself, one usually focused on a specific geographic location and time of year. In the *Waterloo Bridge* series, he rented a room in London during the winter months in order to capture the most intense periods of coal-produced smog, which, he claimed gave the city its "magnificent breadth" and "mysterious cloak."[34]

A more immediately obvious pictorial influence on Farb are De Kooning's paintings from 1975 through 1978, which possess a "gutsiness, brashness, [and] intensity" she says still inspire her.[35] Bravura works such as *Untitled XI* (fig. 5) show De Kooning moving from his semifigural, choppy, violent *Women* compositions of the 1950s and 1960s to more fully abstract, gestural, and lyrical images, signaling his permanent relocation to the Long Island countryside. The thick, impastoed passages of paint are worked and reworked, layer upon layer, not unlike Farb's canvases, which are densely built up, if less overtly gestural. Although his pictures no longer represented exterior reality, De Kooning still worked from nature and was particularly moved to represent

[32] Catherine Firmin-Didot, "Monet vu par quinze artistes contemporains," *Télérama Hors-Série* (May 1999), p. 75.
[33] Farb-Clarke interview (note 1).

[34] Quoted in Grace Seiberling, *Monet in London* (Atlanta: High Museum of Art, 1988), pp. 54–55.
[35] Farb-Clarke interview (note 1)

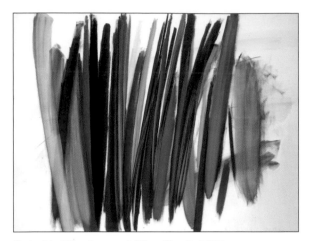

Cat. 14: *Weather and Sky, No. 6*, 2000.

the evanescence of the water that surrounded him in his East Hampton home. Farb's more controlled bands of color, such as those in *Weather and Sky, No. 5* (cat. 13) are entirely different from De Kooning's curved, allover, uncontrolled application of paint, but the intensely worked passages have the same "brash and gutsy" effect on the viewer.

So if abstraction is decidedly anti-hip today and has been so for at least the past two decades, then how and why does Farb continue in her defiant, even hermetic approach to painting? The critic Yves Michaud posed a related question in 1988, asking Farb, "Do you think art has any critical value or form of social integration, or do you work in a relatively autonomous or indifferent way in regard to society?" To this, she answered, "The act of painting is, in itself, a sort of proclamation, a distancing from the preoccupations of society in general . . . I consider that my painting is more readable on a formal level than as an indication of political, social, or dogmatic attitudes."[36] Farb clearly sees painting as an interiorized turning away from society and politics, a kind of refuge. In her desire to define her art as formal rather than sociopolitical, she in fact creates her own manner of dogmatism, her own decidedly antitheoretical theory of abstraction.

According to Farb, "for me the act of painting is a necessity, a drive, an urgency."[37] We sense this urgency, this power and force, in the magnificence of her canvases. In many ways, her defiance in the face of "hip" recalls that of her recently deceased mentor Champa: he wrote and taught what he liked, and detractors stand clear. Despite an open heart and a willingness to accept differing opinions, he believed what he believed and had a legion of followers and supporters, as does Farb. Is it truly necessary to set one's art within a theoretical frame, some pre-ordained school of thought? In the case of an artist like Farb, the absence of such a momentarily chic conceptual road map and the call to look, and look hard—can be just as enticing.

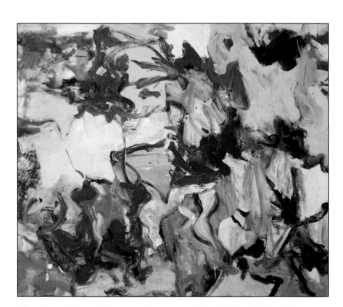

Fig. 5: Willem De Kooning. *Untitled, XI*, 1975. Oil on canvas. 195.6 x 223.5 cm (77 x 88 in.). The Art Institute of Chicago. Through prior acquisitions of John J. Ireland and Joseph Winterbotham; Walter Aitken Endowment, 1983.792. Photograph © The Art Institute of Chicago.

[36] Yves Michaud, *Carte Blanche à Yves Michaud*, exh. cat. (Ivry-sur-Seine: Centre d'art d'Ivry, 1988), p. 12.

[37] Farb-Ziegler interview (note 15).

Adrienne Farb and the Anti-Hip of Abstraction

Chronology

Erin Murray, Independent Scholar

1956

Birth of Adrienne Farb on August 28 in Chicago, to Leonard and Leanora Farb.

Leonard was a designer and graphic artist, Leanora a pianist.

1960s

As a child, Farb visits the Art Institute of Chicago on an almost weekly basis and takes classes there; she also accompanies her parents to many concerts by the Chicago Symphony Orchestra.

1970s

Spends summers and extended sojourns in Oaxaca, Mexico, throughout the early and mid-1970s.

1978

Studying under Kermit Champa, who becomes her mentor, Farb graduates from Brown University magna cum laude with a major in the History of Art. She spends the summer of this year at the New York Studio School, working on drawings and paintings on paper; she also discusses her work with Brice Marden, a visiting artist at the school. In the fall, she arrives in Paris, where she is granted a studio at Fondation des États-Unis at Cité Universitaire for one year.

1980

The American Center in Paris awards Farb a studio for two years at Cité Internationale des Arts.

1981

First solo show in 1981 at Elise Meyer Gallery, New York.

1982–1985

Solo exhibitions at Watson Gallery at Wheaton College, Watson, Massachusetts; 57 Laight Street, New York; and Barbara Tamerin Fine Arts, New York. Participates in group shows including those at Galerie le Dessin and Salon de Montrouge.

1985

Farb is chosen to exhibit in *La Voie Abstraite* at the Hôtel de Ville de Paris. Farb's first major show in the city, it is curated by Yves Michaud, who becomes an important supporter of her work, writing many articles and essays for exhibition catalogues. Michaud introduces Farb to Bernadette Chirac, the wife of the mayor, who helps her procure an artist's studio sponsored by the city of Paris.

1986

Begins teaching drawing, painting, and contemporary art at Southern Methodist University in Paris, a position she holds until 1996.

1987

First solo exhibit at the Galerie Zurcher, Paris; this is the start of a thirteen-year relationship marked by solo shows every two years.

1988

Yves Michaud selects Farb's work for the group show *Carte Blanche à Yves Michaud* at the CREDAC in Ivry-sur-Seine, outside of Paris.

1989

Farb's work appears in the *41st Annual Purchase Exhibition* at the American Academy of Arts and Letters, New York.

1990

Travels to Alexandria, Egypt, for the *Exhibition of Egyptian and American Art*, a group show sponsored by the American Embassy at the American Cultural Center.

Exhibits in the group show *Visititng Artists* at the Cantor Art Gallery at the College of the Holy Cross, Worcester, Massachusetts.

1990 (*continued*)

Works as a visiting artist at Southern Methodist University in Dallas, Texas.

1991

A selection of Farb's paintings is exhibited in *Collection d'Art Contemporain de la BNP (Banque Nationale de Paris)* at the École Nationale Supérieure des Beaux-Arts, Paris. Throughout the previous decade, the Banque Nationale de Paris had purchased nine of her works, incorporating them into their collection in Brussels, Louveciennes, New York, Paris, and San Francisco.

1992

Farb begins teaching painting and drawing in the adult education program at the École Nationale Supérieure des Beaux-Arts, where she continues through 2003.

Fonds Régional d'Art Contemporain d'Île-de-France acquires one of Farb's paintings for its permanent collection in 1992 and another in 1993.

1993

Granted French citizenship.

Major show with American artist David Budd at the Musée de Maubeuge in northern France.

1993 (*continued*)

Spends the summer as an artist-in-residence in Desvres, France, working in ceramics on a commission from the city of Desvres and la Maison de la Faïence, Desvres.

French television station FR3 produces a film on Farb's work that features interviews with Charlotte Eyerman, Yves Michaud, and Bernard Zurcher.

1995

Fiancé Clément Bernard moves to London for professional reasons. Farb commutes between London and Paris, teaching at the École Nationale Supérieure des Beaux-Arts on Saturdays.

Solo exhibitions at Galerie Pierre Colt, Nice, in 1994 and 1995.

1997

Farb marries Clément Bernard in Paris on July 18. She maintains studios both in Paris and Bromley-by-Bow, London.

Solo show at Centre Régional d'Art Contemporain, Montbéliard, organized by Philippe Cyroulnik with catalogue essay by Yves Michaud.

2001

Farb and Clément Bernard move to New York.

2002

Work shown in *Alumni Exhibition, New York Studio School* at Elizabeth Harris Gallery, New York, curated by Karen Wilkin and Judd Tully.

2004

Solo exhibition of new work at the Lohin-Geduld Gallery, New York.

Paintings featured in *Band of Abstraction* at Van Brunt Gallery, New York, curated by Joe Fyfe.

2005

New paintings shown alongside the work of artist Robert Stuart in *Glow*, Mary Ryan Gallery, New York.

Farb's paintings are featured in the group show *40 Petits Formats*, Galerie Jean Fournier, Paris.

Selected Bibliography

Anger, Jenny. *Paul Klee and the Decorative in Modern Art.* Cambridge: Cambridge University Press, 2004, pp. 205–206.

Carbonnet, Muriel. "La-Haut sur la Colline." *Demeures et Châteaux* 126 (2001), pp. 106–109.

Champa, Kermit S. "Adrienne Farb." *Arts Magazine* 55 (1981), p. 11.

——. "Neo-Modernism and the Painting of Adrienne Farb." *Arte Factum* 3 (1986), pp. 24–27.

——. "Adrienne Farb." *Art Press* 138 (July–August 1989), p. 78.

——. *Adrienne Farb*, exh. cat. (Paris: Galerie Zurcher, 1991).

——. *Adrienne Farb: Glimpse of the Moon*, exh. brochure (New York: Lohin-Geduld Gallery, 2004).

Durozoi, Gérard. *David Budd et Adrienne Farb*, exh. cat. (Maubeuge: Musée de Maubeuge, 1993), pp. 1–5.

Firmin-Didot, Catherine. "Monet vu par quinze artistes contemporains." *Télérama Hors-Série* (May 1999), p. 75.

——. "Gauguin vu par dix artistes contemporains." *Télérama Hors-Série* (October 2003), pp. 88–89.

Grenier, Alexandre. "Adrienne Farb . . . et zou!" *Pariscope* 1541 (December 3–9, 1997), p. 79.

——. "Adrienne Farb—Direct au coeur!" *Pariscope* 1623 (June 30–July 6, 1999), p. 166.

Michaud, Yves. *Peinture: La Voie Abstraite* (Paris: Hôtel de Ville, 1985), pp. 2–4, 12–17.

——. *Carte Blanche à Yves Michaud*, exh. cat. (Ivry-sur-Seine: Centre d'art d'Ivry, 1988), pp. 5, 10–13.

——. *The BNP Contemporary Collection*, exh. cat. (Paris: BNP, 1991), pp. 62–63.

——. "Adrienne Farb." In *L'Ame du Fonds*, exh. cat. (Île-de-France: Collection de FRAC, 1994), pp. 48–49.

——. *Les Marges de la Vision* (Paris: Jacqueline Chambon, 1996), p. 275.

——. "Flagrant présence." In *Adrienne Farb*, exh. cat. (Montbéliard: Centre Régional d'Art Contemporain, 1997), pp. 3–31.

——. *Ateliers au Féminin* (Paris: Au même titre, 1999), pp. 112–117.

Panero, James. "Gallery Chronicle." *New Criterion* 23 (May 2005), pp. 48–49.

Pinte, Jean-Louis. "Adrienne Farb, Plein–Soleil." *Figaroscope* 14430 (January 16–22, 1991), p. 49.

———. "Les Nouveaux talents sont des femmes." *Figaro Madame* 15905 (October 7, 1995), pp. 64–65.

———. "L'Interiorité d'Adrienne Farb." *Atmosphères* 13 (November 1997), p. 11.

Ruby, Robert. "Adrienne Farb." In *Figures et Paysages*, exh. cat. (Paris: FRAC, 1997), pp. 42–43.

Vezin, Luc. "Les Motifs d'Adrienne Farb." *Beaux-Arts Magazine* 87 (February 1991), p. 123.

Walentini, Joseph. "Adrienne Farb at the Lohin-Geduld Gallery." *Abstract Art Online* (May 28, 2004). www.abartonline.com.

———. "Adrienne Farb at the Mary Ryan Gallery." *Abstract Art Online* (April 15, 2005). www.abartonline.com.

Wat, Pierre. "Courbes effrénées." *Beaux-Arts Magazine* 160 (September 1997), p. 24.

Exhibition Checklist

Paris Years

1. *Luxembourg Rain*, 1980
Oil on linen
45 x 55 cm (18 x 21 3/4 in.)
Former collection of Kermit S. Champa

2. *Sable blanchi avec la teinte foncée*
(White Sand with Darkness), 1984
Oil on linen
100 x 100 cm (39 1/2 x 39 1/2 in.)
Courtesy of the artist

3. *Truite, No. 3* (Trout, No. 3), 1987
Oil on linen
111 x 150 cm (43 3/4 x 59 in.)
Courtesy of the artist and Mary Ryan Gallery,
New York

4. *Rouget*, 1988
Oil on linen
10 x 20 cm (4 x 7 3/4 in.)
Collection of Joanna E. Ziegler

5. *Tuileries, No. 6*, 1988
Oil on linen
195 x 112 cm (76 3/4 x 44 1/8 in.)
Courtesy of the artist

6. *Luxembourg Night, No. 1*, 1989
Oil on linen
50 x 100 cm (19 1/2 x 39 1/2 in.)
Courtesy of the artist

7. *Luxembourg, No. 2*, 1989
Oil on linen
162 x 195 cm (64 x 77 in.)
Former collection of Kermit S. Champa

London Years

8. *Funghi Porcini, No. 4*
(Porcini Mushrooms, No. 4), 1997
Oil on linen
61 x 46 cm (24 x 18 in.)
Collection of Clément Bernard

9. *Avalanche, No. 4*, 1999
Oil on linen
185 x 92 cm (72 3/4 x 36 1/4 in.)
Courtesy of the artist

10. *Petit Nero di Seppia, No. 1*
(Squid Ink, Small Version, No. 1), 1999
Oil on linen
60 x 20 cm (24 x 8 in.)
Courtesy of the artist and Mary Ryan Gallery,
New York

11. *Petit Nero di Seppia, No. 2*
(Squid Ink, Small Version, No. 2), 1999
Oil on linen
60 x 20 cm (24 x 8 in.)
Courtesy of the artist and Mary Ryan Gallery,
New York

12. *Weather and Sky, No. 2*, 2000
Oil on linen
50 x 100 cm (19 3/4 x 39 1/2 in.)
Courtesy of the artist

13. *Weather and Sky, No. 5*, 2000
Oil on linen
50 x 100 cm (19 3/4 x 39 1/2 in.)
Courtesy of the artist

14. *Weather and Sky, No. 6*, 2000
Oil on linen
140 x 185 cm (55 x 72 3/4 in.)
Collection of Clément Bernard

New York Years

15. *Bouquet Final, No. 2*
(Final Flower, No. 2), 2001–02
Oil on linen
100 x 185 cm (39 1/2 x 72 3/4 in.)
Courtesy of the artist and Mary Ryan Gallery,
New York

16. *Petit Fiori di Zucca, No. 4*
(Zucchini Blossoms, Small Version, No. 4),
2002
Oil on linen
25 x 20 cm (9 3/4 x 8 in.)
Courtesy of the artist

17. *Fiori di Zucca, No. 6*
(Zucchini Blossoms, No. 6), 2002
Oil on linen
185 x 130 cm (72 3/4 x 51 in.)
Courtesy of the artist and Mary Ryan Gallery,
New York

18. *Petit Urbino, No. 1*
(Urbino, Small Version, No. 1), 2002
Oil on linen
28 x 61 cm (10 1/2 x 24 in.)
Courtesy of the artist and Mary Ryan Gallery,
New York

19. *Those Cool September Mornings, No.1*,
2003
Oil on linen
185 x 140 cm (72 3/4 x 55 in.)
Courtesy of the artist and Mary Ryan Gallery,
New York

20. *Those Cool September Mornings, No. 2*,
2003–04
Oil on linen
195 x 100 cm (76 1/4 x 39 1/2 in.)
Courtesy of the artist and Mary Ryan Gallery,
New York

21. *Bouleversement, No. 3*
(Upheaval, No. 3), 2004
Oil on linen
160 x 160 cm (63 x 63 in.)
Courtesy of the artist and Mary Ryan Gallery,
New York

22. *Always and Forever, No. 1*, 2005
Oil on linen
185 x 140 cm (72 3/4 x 55 in.)
Courtesy of the artist and Mary Ryan Gallery,
New York

23. *Parmi les Éclairs, No. 1*
(Amidst the Lightning, No. 1), 2005
Oil on linen
120 x 185 cm (47 1/4 x 72 3/4 in.)
Courtesy of the artist and Mary Ryan Gallery,
New York

24. *Parmi les Éclairs, No. 8*
(Amidst the Lightning, No. 8), 2005
Oil on linen
103 x 66 cm (40 1/2 x 26 in.)
Courtesy of the artist and Mary Ryan Gallery,
New York

25. *Parmi les Éclairs, No. 9*
(Amidst the Lightning, No. 9), 2005
Oil on linen
103 x 66 cm (40 1/2 x 26 in.)
Courtesy of the artist and Mary Ryan Gallery,
New York

26. *Palermo, No. 3*, 2006
Oil on linen
150 x 100 cm (59 x 39 1/2 in.)
Courtesy of the artist and Mary Ryan Gallery,
New York

27. *Encre, No. 14* (Ink, No. 14), 2006
Brush with colored inks mixed with shellac
on paper
77 x 57 cm (30 1/4 x 22 1/2 in.)
Courtesy of the artist and Mary Ryan Gallery,
New York

28. *Becoming Night, No. 1*, 2006
Oil on linen
100 x 50 cm (39 1/2 x 19 3/4 in.)
Courtesy of the artist and Mary Ryan Gallery,
New York

29. *Becoming Night, No. 3*, 2006
Oil on linen
53 x 46 cm (21 x 18 in.)
Courtesy of the artist and Mary Ryan Gallery,
New York

Plates

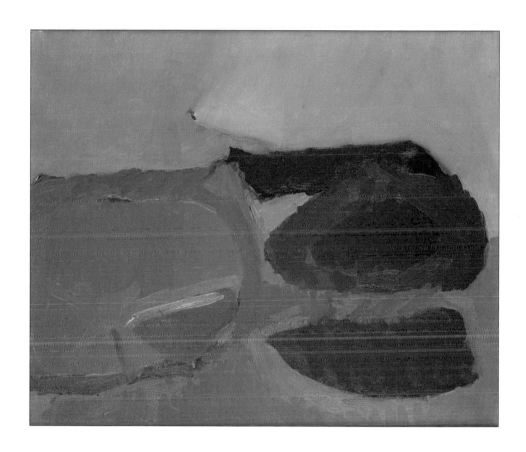

1. *Luxembourg Rain*, 1980

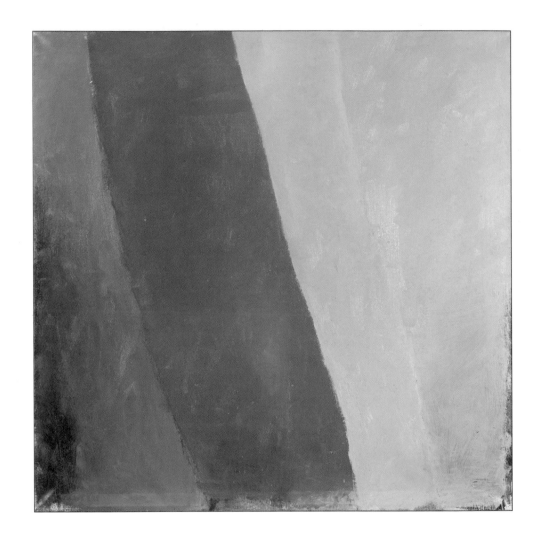

2. *Sable blanchi avec la teinte foncée* (White Sand with Darkness), 1984

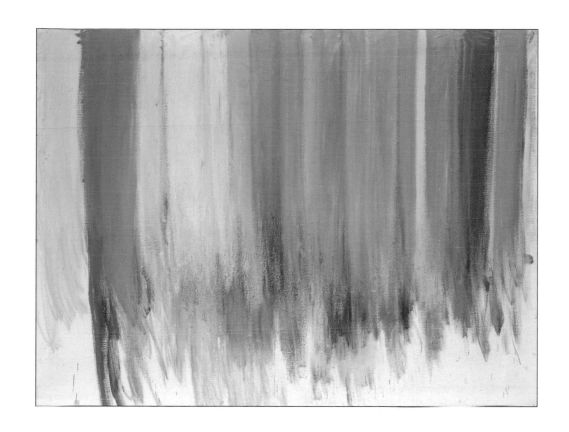

3. *Truite, No. 3* (Trout, No. 3), 1987

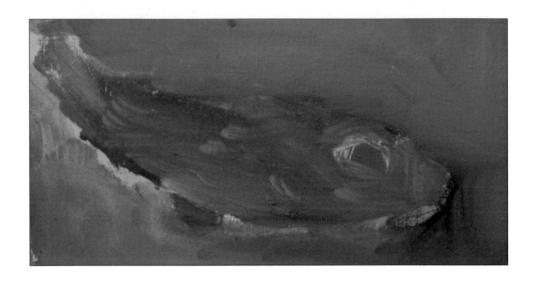

4. *Rouget*, 1988

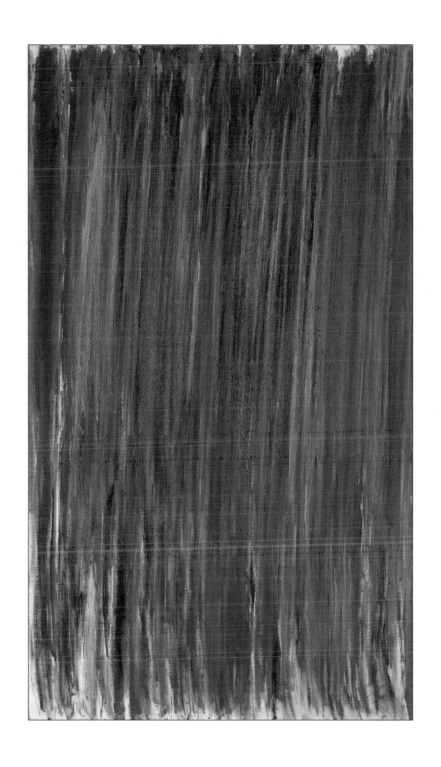

5. *Tuileries, No. 6*, 1988

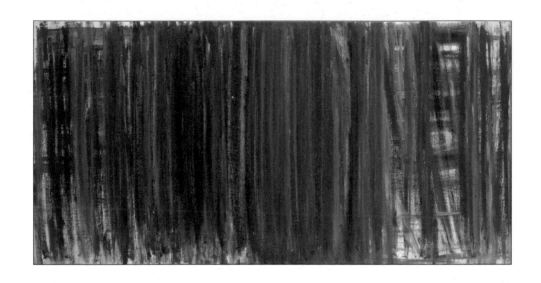

6. *Luxembourg Night, No. 1*, 1989

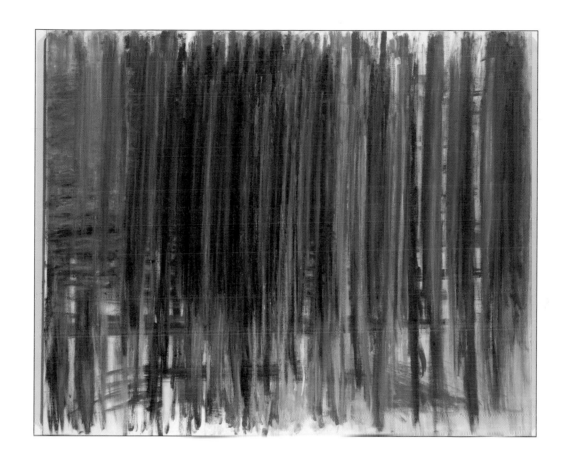

7. *Luxembourg, No. 2*, 1989

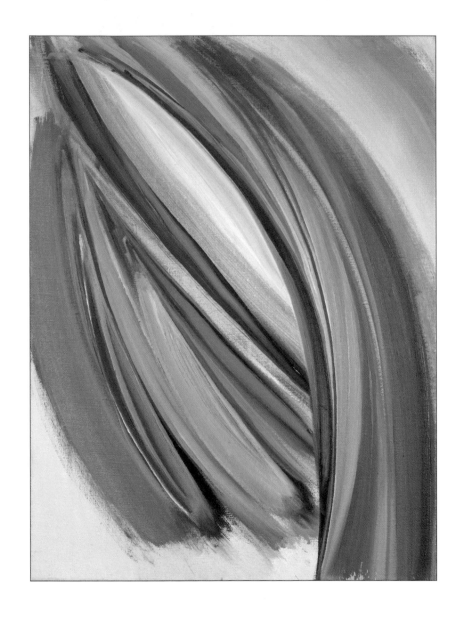

8. *Funghi Porcini, No. 4* (Porcini Mushrooms, No. 4), 1997

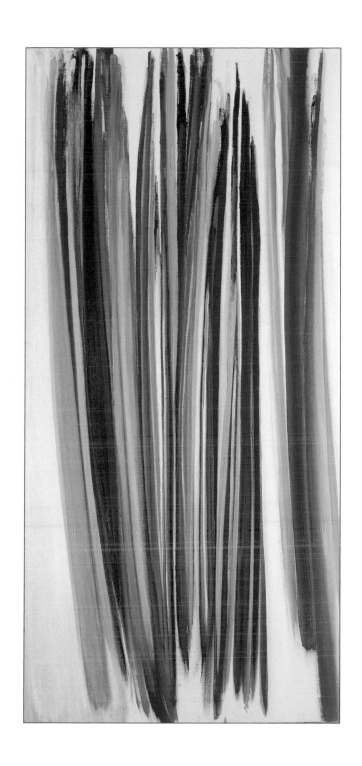

9. *Avalanche, No. 4*, 1999

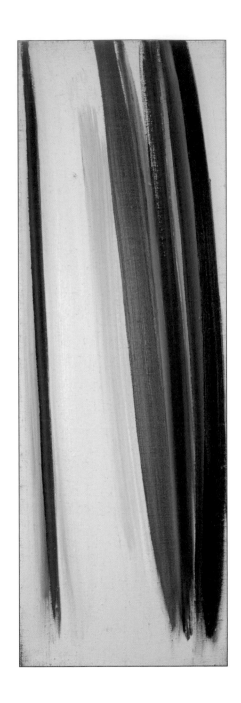

10. *Petit Nero di Seppia, No. 1* (Squid Ink, Small Version, No. 1), 1999

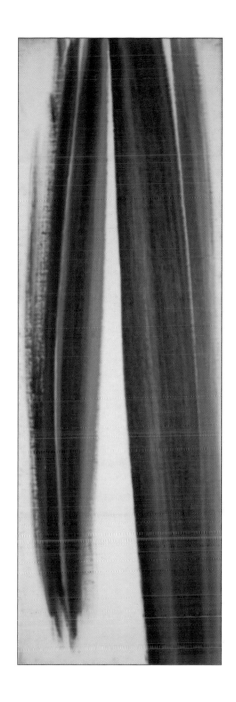

11. *Petit Nero di Seppia, No. 2* (Squid Ink, Small Version, No. 2), 1999

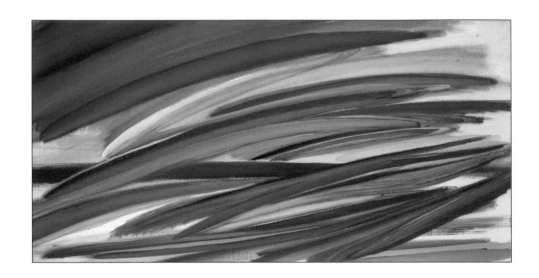

12. *Weather and Sky, No. 2,* 2000

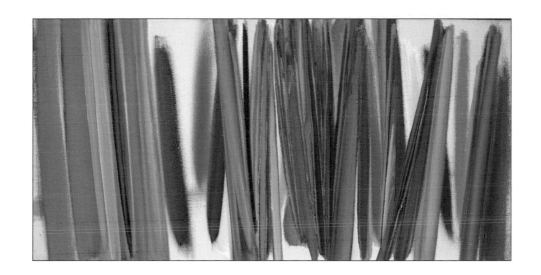

13. *Weather and Sky, No. 5, 2000*

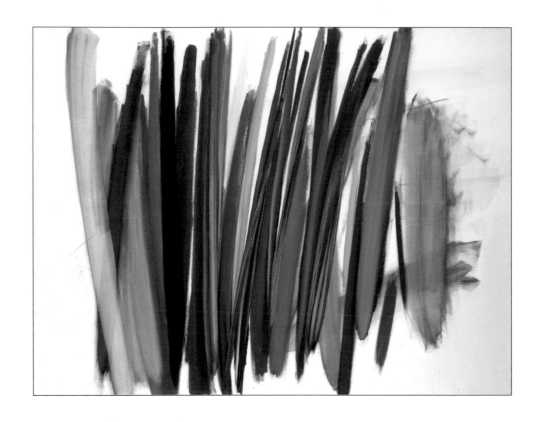

14. *Weather and Sky, No. 6*, 2000

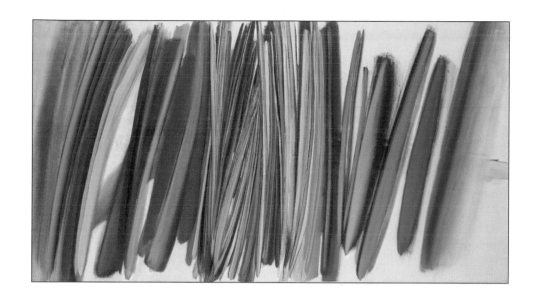

15. *Bouquet Final, No. 2* (Final Flower, No. 2), 2001–02

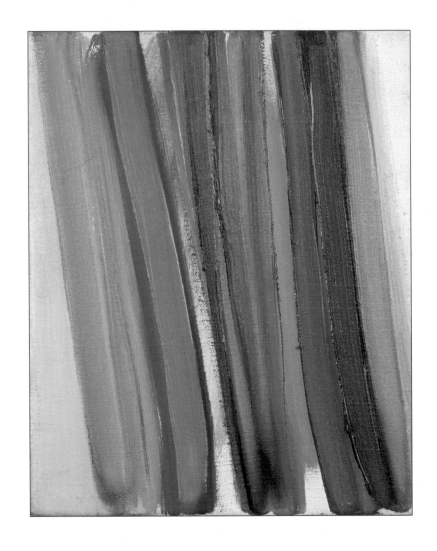

16. *Petit Fiori di Zucca, No. 4* (Zucchini Blossoms, Small Version, No. 4), 2002

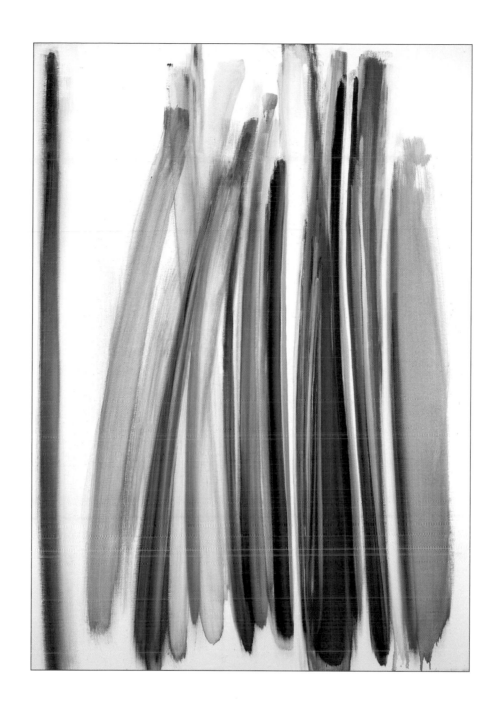

17. *Fiori di Zucca, No. 6* (Zucchini Blossoms, No. 6), 2002

18. *Petit Urbino, No. 1* (Urbino, Small Version, No. 1), 2002

19. *Those Cool September Mornings, No.1*, 2003

20. *Those Cool September Mornings, No. 2,* 2003–04

21. *Bouleversement, No. 3* (Upheaval, No. 3), 2004

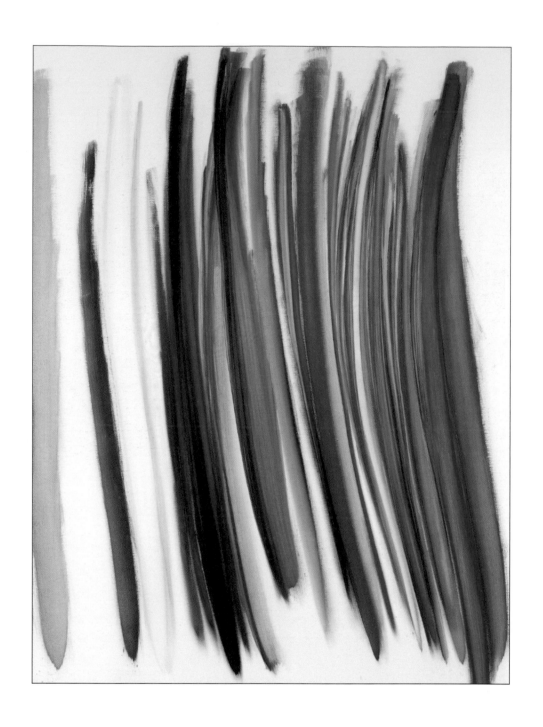

22. *Always and Forever, No. 1*, 2005

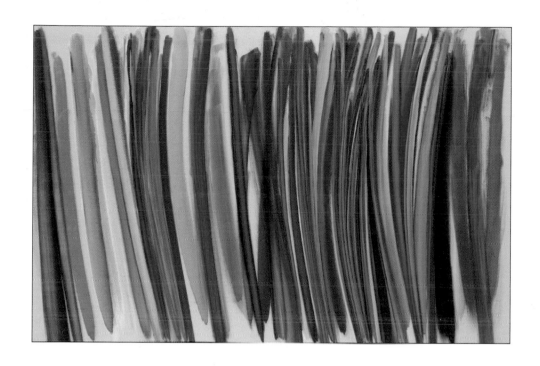

23. *Parmi les Éclairs, No. 1* (Amidst the Lightning, No. 1), 2005

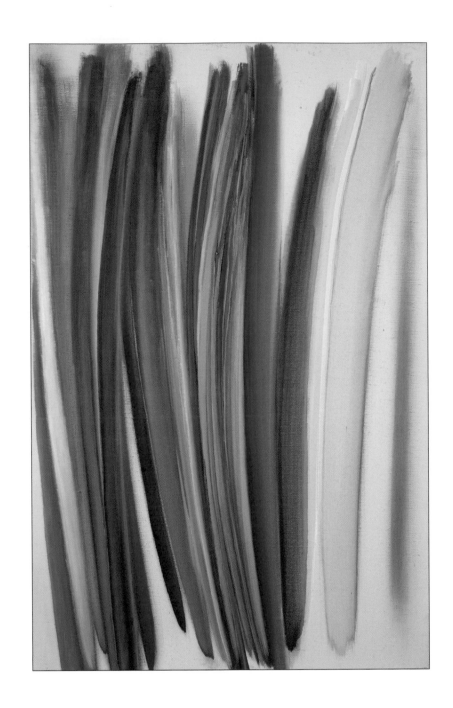

24. *Parmi les Éclairs, No. 8* (Amidst the Lightning, No. 8), 2005

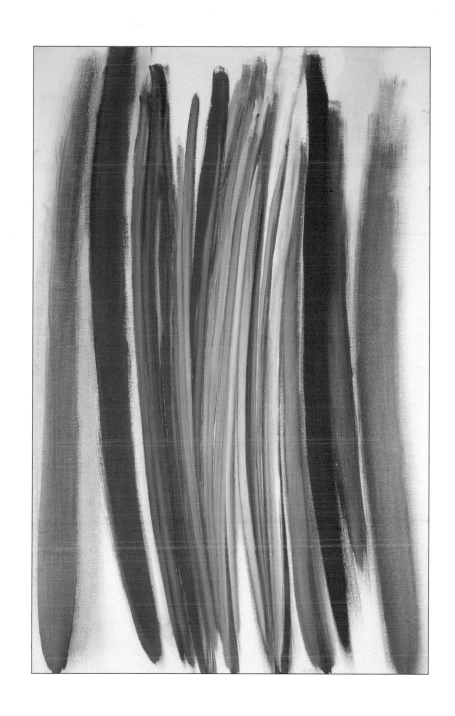

25. *Parmi les Éclairs, No. 9* (Amidst the Lightning, No. 9), 2005

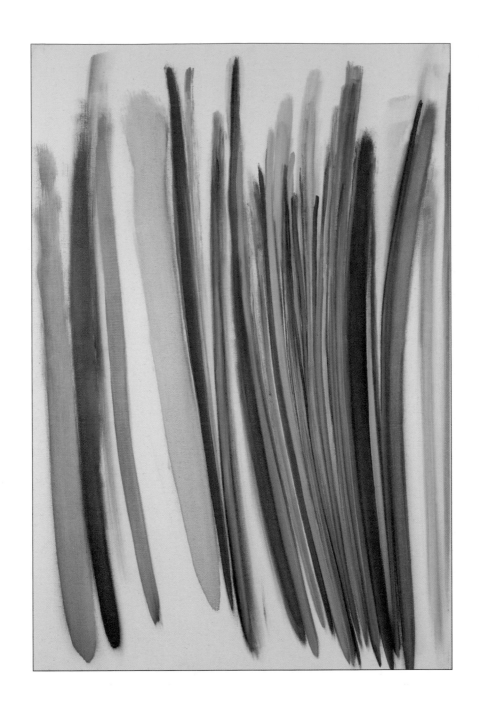

26. *Palermo, No. 3*, 2006

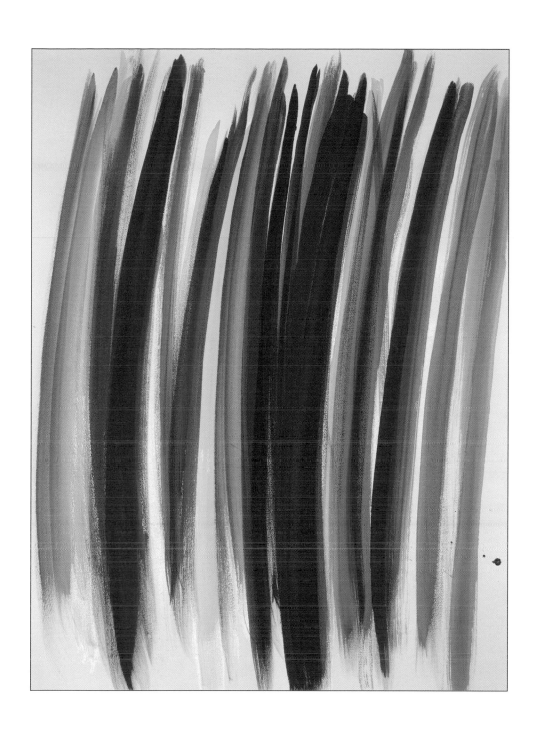

27. *Encre, No. 14* (Ink, No. 14), 2006

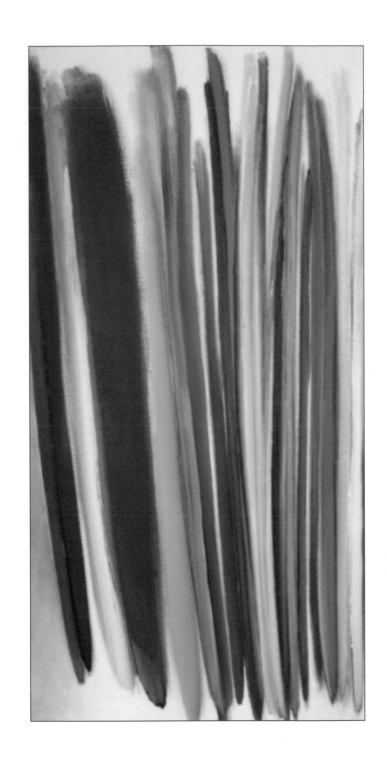

28. *Becoming Night, No. 1*, 2006

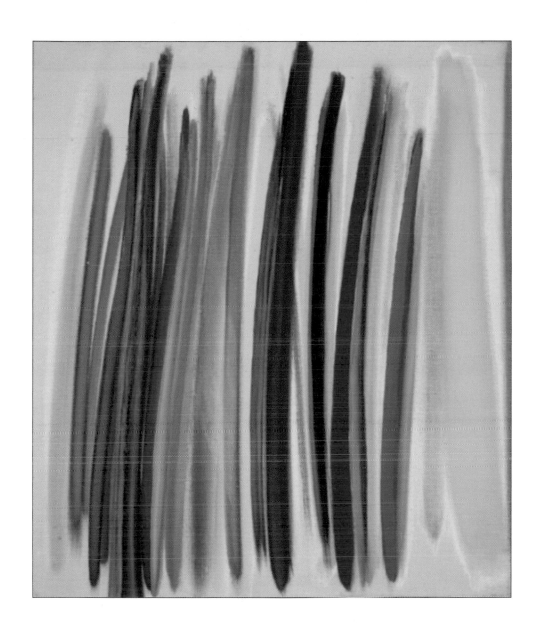

29. *Becoming Night, No. 3*, 2006